IMAGES
of America

# THE AUSTIN DAM
# DISASTER OF 1900

IMAGES
*of America*

# THE AUSTIN DAM
# DISASTER OF 1900

Elizabeth H. Clare

ARCADIA
PUBLISHING

Published by Arcadia Publishing
Charleston, South Carolina

Printed in the United States of America

Library of Congress Control Number: 2017940644

For all general information, please contact Arcadia Publishing:
Telephone 843-853-2070
Fax 843-853-0044
E-mail sales@arcadiapublishing.com
For customer service and orders:
Toll-Free 1-888-313-2665

Visit us on the Internet at www.arcadiapublishing.com

*For my sister Mary*
*"Shake and Bake"*

# CONTENTS

# Acknowledgments

The author wishes to thank all of the institutions that preserve and make available archival materials so that history can live. Mike Miller and the staff of the beautiful Austin History Center, where the bulk of the research was conducted, were critical to the success of this project. Their image library is a thing of wonder. I would also like to thank Melinda Church of the corporate archives at the Lower Colorado River Authority and the staff of the Texas State Library and Archives Commission for their assistance in locating additional images for this book. In addition, the Portal to Texas History at the University of North Texas has become an invaluable resource for any Texas image project. Additional research was conducted at the University of Texas at Austin and its magnificent libraries.

All images in this work appear courtesy of the Austin History Center unless otherwise noted.

# INTRODUCTION

In the 21st century, we Americans have a luxury unimaginable for most of human history—a rich heritage of infrastructure, most of it conceived, designed, and sweated over by our ancestors. When we want to go someplace, we can pull into the highway and drive for hundreds or thousands of miles on roads and bridges they built. Their legacy of delivering electricity and wireless have given us the ability to effortlessly connect, the world at our fingertips, by means few of us understand.

Then there is the water infrastructure they built, men digging trenches in the clay by hand under the blaze of a long-ago summer sun, still bringing us clean water at any time of the day or night to quench our thirst, take a shower, or wash our clothes. And it is their understanding of flood control and hydraulics, wrung out of disasters so terrible they were called "acts of God," that has enabled growth and prosperity beyond imagining for the cities along America's great rivers.

Austin, Texas—my hometown along the mighty Colorado—is one of those cities. Today a booming "technopolis" of some two million people, Greater Austin is one of the fastest-growing urban areas in the United States. It is famous for hipsters and live music festivals, Sixth Street nightlife and morning-after breakfast tacos, world-class barbecue, and a world-class research university—not to mention a chain of lakes carved from the river in the 1930s and 1940s. It is hard to imagine a city more emblematic of "the built environment"—the human-made experience where we live, work, and play—than contemporary Austin. Perhaps only the bats on their nightly flight from their roost underneath the Congress Avenue Bridge serve to remind us that nature may still have a few surprises for us.

The Austin Dam disaster of 1900 illuminates the journey of Austin from dusty frontier capital to modern-day tech magnet. In 1839, Edwin Waller, Austin's first mayor, laid out a grid along the Colorado River between Shoal Creek and his namesake Waller Creek. Initially, the city's founders dreamed of steamboats traveling upriver and canals that would attract industry to the area. Instead, they had chosen one of the most flood-prone regions on the planet. Located at the intersection of powerful weather systems from the Great Plains, Pacific Coast, and the Gulf of Mexico, Austin sits atop the unique geography of the Balcones Fault, a rugged limestone escarpment that seems almost designed by nature to scour the land with devastating flash floods.

Enter the Austinites—then as now, many of them of them arrivals from someplace else, who fell in love with the potential of this spot and were determined to realize it, even at the expense of transforming it into something else altogether. Could there be anything more "Austin" than rushing headlong into the construction of not just any dam, but the largest dam ever built in the 19th century on the assumption that industries from around the world would then beat a path to the River City?

The forgotten disaster of the dam's failure is even more revealing. Few cities like to remember their failures, and Austin is no exception. It is never pleasant to remember pain, chaos, and destruction, especially not when one's own hubris and bad decisions were at the root of them. For our forebears, the Austin dam disaster was an inescapable burden for three decades after that terrible day in April 1900, crushing the city under a mountain of debt and harsh realities. No city, no region can sustain growth without a supply of clean water, a means to generate electricity, and a way to mitigate the effects of natural disasters. With titanic effort and skillful leveraging of technology and government, Austinites clawed their way out. In fact, they did such a good job, we may be in danger of taking their work for granted. In this era of go-go growth, it may be useful to remember that not every idea is a good idea and that work of lasting value must be recognized, appreciated, and maintained.

As a lifelong Austinite, I grew up in a city still celebrating the taming of the Colorado by the Highland Lakes dams. Aquafest attracted thousands every summer to celebrate the existence of Town Lake. The hike and bike trail and beautification of the lake was an ongoing project. Lake Austin meant fishing camps and hamburgers at the Pier, and the iconic Pennybacker Bridge was still under construction.

Of course, Central Texas did not cease to be "flash flood alley" after the dams were built, and anyone who has lived here any length of time has his or her own close calls to relate. I wish I could claim my interest in disasters stemmed from some dramatic experience during the unforgettable Memorial Day flood of 1981. Fortunately, my teenage self experienced only minor flooding in the house, and my mother pitched in to wash flood-soaked clothes for less fortunate neighbors.

The concept for this book began years ago when I learned that Red Bud Isle—now a beloved dog park—was formed from the wreckage of the old Austin dam. The idea germinated for many years as I coauthored two books about Lewis and Clark under the pen name Frances Hunter, worked at the Texas State Library and Archives preparing historical exhibits, and assisted as a researcher with other works of Texas history. The popularity of these projects made me realize that, given a chance, people really do love to rediscover their own history.

It has been said that we love disaster stories because they strip us down to the core of our beings: Why did this happen? Would I have made the same choices? Would I have faced reality sooner than they did? Would I have the grit to come back from a tragedy I played a part in creating? For me, the story of the Austin Dam disaster raises these questions and more. It also sheds a meaningful spotlight on the culture of civic life in Austin, how decisions are made and for what reasons. The legacy of the past is with us whether we choose to acknowledge it. Through the Austin Dam disaster, we can learn from the mistakes of those who came before, understand how the disaster still touches our lives today, and gain wisdom for fulfilling our own responsibilities to the future.

# One

# AUSTIN BEFORE THE DAM

In the beginning, there was the Colorado. The largest river within the state of Texas, it originates in the desert of the Llano Estacado and travels 862 miles through the rugged Hill Country and weathered limestone of the Balcones Fault before emptying the Gulf of Mexico at Matagorda Bay. Most years, the Colorado carries 600 billion gallons of water, draining about 16 percent of the total area of the state.

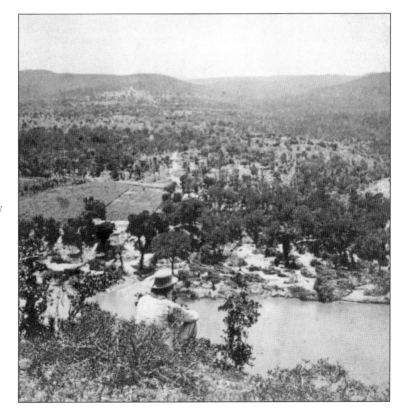

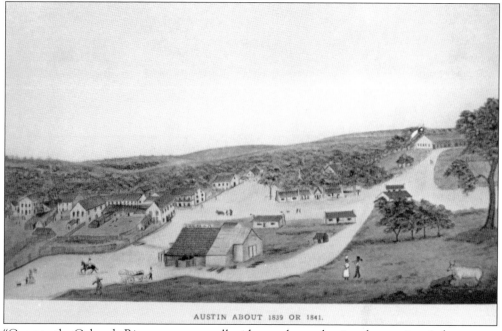

AUSTIN ABOUT 1839 OR 1841.

"Came to the Colorado River—poor, gravelly ridges and near the river, heavy pine timber, grapes in immense quantities on low vines, red, large, and well flavored, good for red wine," pioneering empresario Stephen F. Austin wrote in 1821 when he first saw the area that would one day bear his name. At the future Austin, the Colorado traveled through a limestone canyon that towered as much as 150 feet above the river.

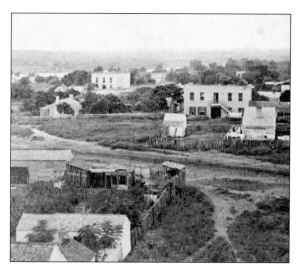

The potential waterpower was one of the factors that led to the selection of Austin as the capital of the Republic of Texas in 1839. But the settlers were soon to learn the truth: the unique combination of severe rain events and the steep rocky hills of Central Texas make it the most flood-prone region in the United States. The first major flood hit the new capital in 1843, though few details were recorded. Natural disasters, Indian attacks, and the Civil War all acted as barriers to Austin's growth. As this 1869 photograph reveals, Austin remained a frontier village whose appearance had scarcely changed with the years.

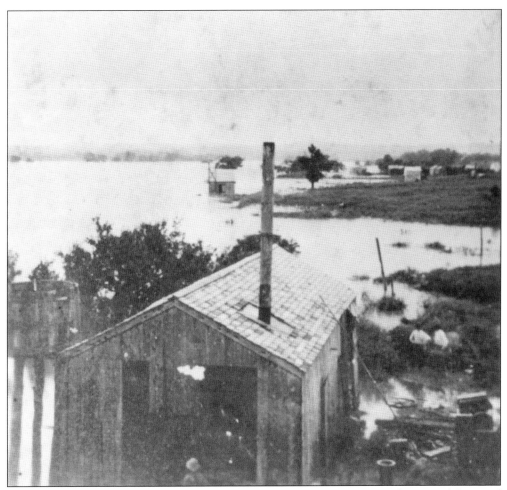

In 1869, a massive flood (still the Austin flood of record) swept away numerous homes and destroyed crops for miles on either side of the river. Cresting at 51 feet, the Colorado River was described as "10 miles wide" and full of dead buffalo. Downstream, Bastrop and La Grange were completely submerged. (Courtesy of the Texas State Library and Archives Commission.)

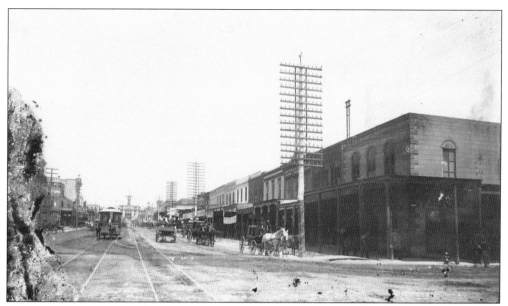

Construction projects in the 1880s reflected the aspirations of Texans and Austinites as they moved on from the Civil War and frontier times. Here at the head of Congress Avenue, a grand new state capitol of Italian Renaissance architecture takes shape. Constructed between 1885 and 1888, the capitol has the distinctive hue of sunset red granite hauled from Marble Falls. Its dedication drew a crowd of 20,000 to the festivities.

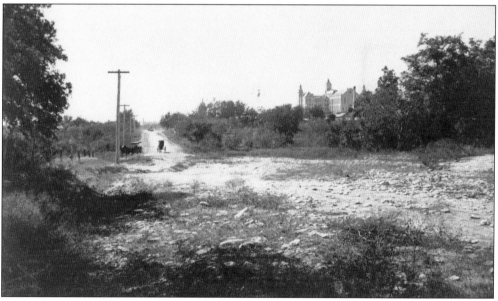

Home to the state government and the University of Texas, which opened its doors in 1883, Austin seemed fated to remain a quiet, tree-lined town presided over by the state capitol's grandeur. This view is from the university looking south towards the capitol. The city government consisted of a fire department and street sweepers.

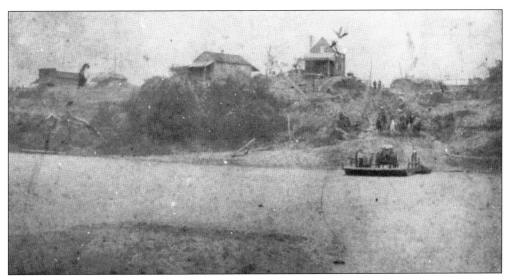

Unnavigable by boat, the Colorado River posed a challenge to early travelers. For the first 30 years of Austin's history, a ferry operated at the foot of Congress Avenue. The most successful was operated by James Swisher, who operated a hotel and tavern to serve his ferry customers. Swisher also established the first post road from Austin to San Antonio. By laying out his road in a direct line from Congress Avenue, Swisher set the stage for the eventual annexation of South Austin as part of the city.

The first bridge across the Colorado was a pontoon bridge constructed in 1869 at the foot of Brazos Street. The floating bridge consisted of 21 boats boarded over with oak flooring. As the *Austin Record* noted, "The bright and sparkling waters of the Colorado, as they go gliding along its banks, laughing in the sunshine seem to say; 'All hail to the invention of man.'" The bridge was destroyed in a flood the following year.

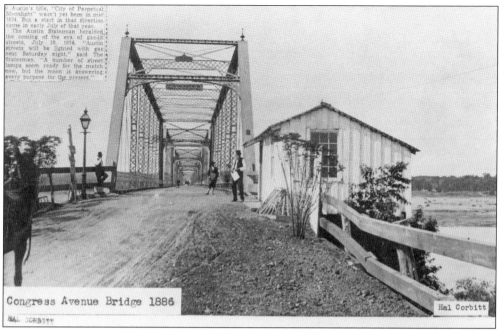

Congress Avenue Bridge 1886

Hal Corbitt

With a population of just 11,000, Austin was being left behind economically by boomtowns like Dallas and Fort Worth. In 1875, the city constructed a wooden toll bridge across the river, which served for seven years until it collapsed under the weight of an ill-advised cattle drive.

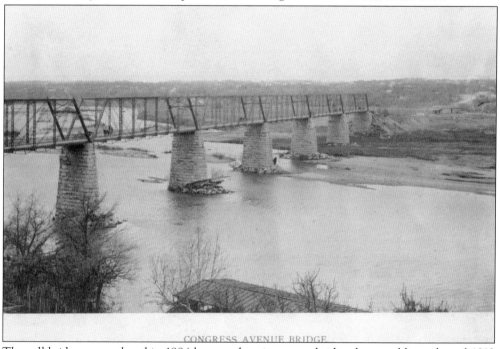

CONGRESS AVENUE BRIDGE

The toll bridge was replaced in 1884 by a modern iron truss bridge that would stand until 1910 when the present-day Congress Avenue Bridge was constructed. Surrounded by fields of cotton and spinach, the two primary crops of the area, the town's largest employers were the state government and local industries such as icehouses, saddlemakers, and machine shops.

Throughout the period, city fathers continued to float ideas that would turn the Colorado into an asset by harnessing it and its local tributaries to power industry, as had been done in northern cities. These ideas included turning Shoal Creek into a canal, building a dam at Bull Creek (seen here), and damming the river at Mount Bonnell to irrigate the farms south of Austin and create a more reliable water supply for the city.

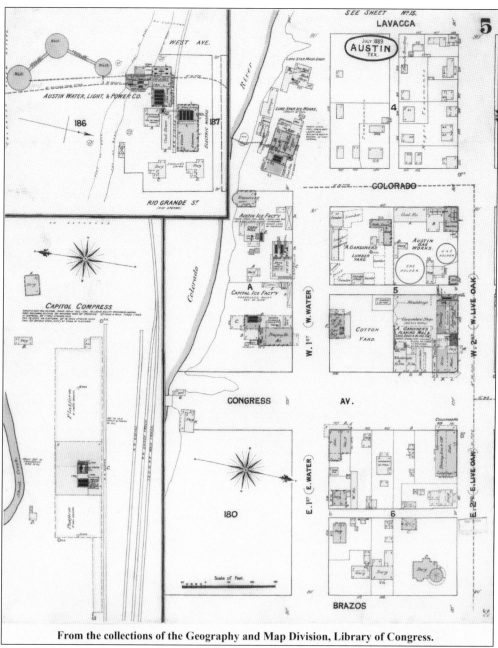

**From the collections of the Geography and Map Division, Library of Congress.**

Like other cities in the 19th century, Austin turned to modern technology to deal with the sewage generated by thousands of people, as well as the risk of catastrophic fires that could spread quickly from building to building. In 1878, Austin Water, Power, & Light began operation as a privately owned utility. The small plant used steam power to draw water from the river at West Avenue and Rio Grande, near the site later used by the Seaholm Power Plant. From the beginning, the water pressure was insufficient to supply homes and fire engines in the higher sections of town. As for the water quality, one resident complained of finding a small catfish in his bathtub. (Courtesy of the Dolph Briscoe Center for American History.)

"In 1888 I originated the idea of the Austin Dam. I was as completely the father of that project as I am the father of any child that I have," wrote Alexander Penn Wooldridge years later. Perhaps Austin's foremost civic leader between 1880 and 1920, Wooldridge began his campaign with an editorial in the *Austin Statesman*, lamenting that the community was "poor and becoming poorer every day." The solution, he wrote, was a "great dam" to attract packeries, canneries, spinning mills, and other industry. Under Wooldridge's plan, the city would offer the power and factory sites free to any manufacturers willing to locate in Austin. (Courtesy of the Texas State Library and Archives Commission.)

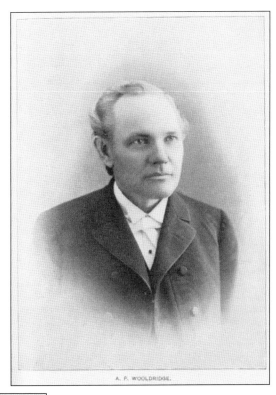

A. P. WOOLDRIDGE.

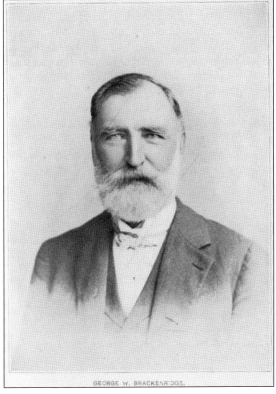

GEORGE W. BRACKENRIDGE.

Two possible spots along the river seemed promising as a location for the dam. The Taylor lime chute (now submerged) was named for Peter Taylor, the operator of several kilns near Bull Creek. With several dozen employees, Taylor's operation was one of the town's major businesses. The Brackenridge tract was owned by George W. Brackenridge, a San Antonio bank tycoon who served on the Board of Regents of the University of Texas. Brackenridge's site took the edge when he offered to donate to the city the right to build the dam and powerhouse on his land. (Courtesy of the Texas State Library and Archives Commission.)

The 1899 mayor's race centered almost exclusively on the dam question. Building contractor John McDonald, a Wooldridge ally, sought to take down incumbent Joseph Nalle, a strong supporter of Austin Water, Power, & Light. Nalle argued that the city's sparse resources should be spent on street repairs, sewers, and parks. McDonald responded that the revenue from the dam would enable the city to pay for all of those things while giving Austinites cheap, reliable water and electricity and creating thousands of new jobs. (Courtesy of the Texas State Library and Archives Commission.)

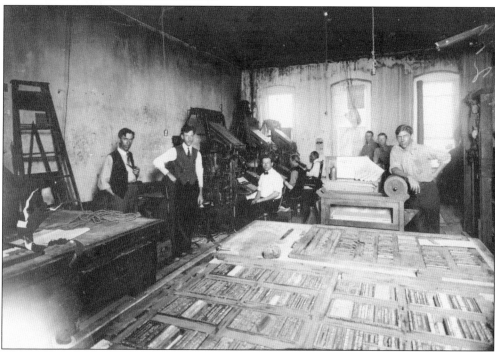

Opponents of the dam included former Texas governor Oran Roberts, then a professor at the University of Texas law school. Roberts called the dam an expensive and risky "white elephant." Even if successful, the dam would bring in "100,000 people and the push and rush of a money-making, crowded population . . . dominated by its mercantile and manufacturing interests." The *Statesman* (offices shown here) steamrolled Roberts's objections. "Give us 100,000 people and to the dogs with our health if we cannot keep it. Give us half a dozen dams. . . . Gracious heavens, how nice that does sound!" McDonald defeated Nalle with 60 percent of the vote, and eight of the ten seats on the city council were won by supporters of the dam project. (Courtesy of the Texas State Library and Archives Commission.)

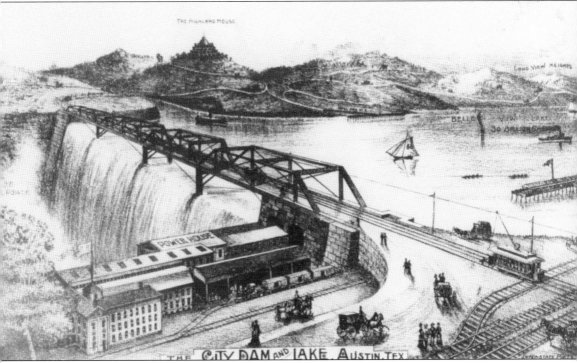

The new council hired Joseph P. Frizell, a respected hydraulic engineer from Boston. On March 26, 1890, a packed-to-capacity crowd at the Austin Opera House was shocked by Frizell's recommendations. To tame the mighty Colorado would require a masonry dam over 60 feet in height—one of the largest in the entire world. The price tag had risen to match, from $150,000 to $1.4 million, including the dam, powerhouse, reservoir, and system for delivering water and electricity to the city. Such a dam would generate over 14,000 horsepower—enough to supply the needs of the entire city and a dozen major factories. A contemporary artist's conception shows the scene of the finished dam. The *Statesman* was giddy: "Last night Austin flung to the breeze the banner under which she will conquer."

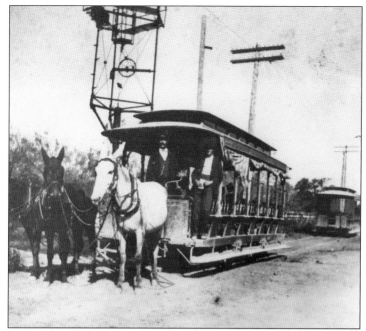

The city appointed a board of public works to oversee the project even before a bond election could be scheduled. Dam fever swept the city. Investors joined to form the town's first large banks, and speculators began buying up land along the routes planned for new streetcars. The *Statesman* gloated, "Don't vote for the dam if you are an irreclaimable rusty old mossback and ready to die." Voters approved the bonds by an astounding tally of 1,354 to 50.

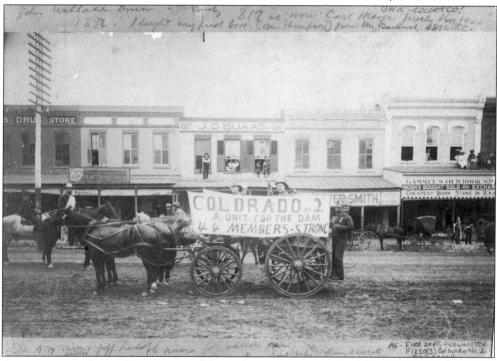

Austinites poured into the streets to celebrate their commitment to the city's future. Skyrockets and bonfires lit the sky on election night, and Congress Avenue and Pecan Street rang with music and laughter far into the night. Now little Austin would take its place among the great cities of America. Few would have disagreed with the *Statesman's* words: "What pitiful argument can be urged except . . . foolish, whimsical theories about dams bursting and overflows. . . . A dam can be built as strong and imperishable as the pyramids of Egypt."

# Two

# CONSTRUCTION

# OF THE DAM

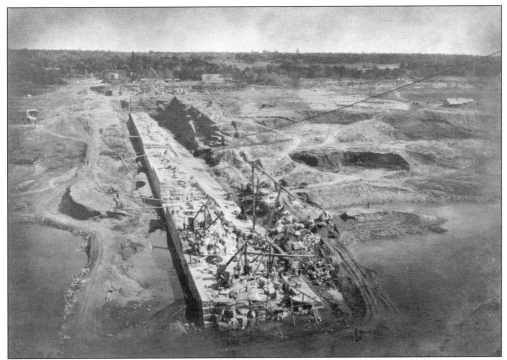

At 66 feet high, 16 feet thick, and 1,100 feet wide, the Austin dam faced the challenge of one of the world's most unpredictable rivers. The dam needed to generate electricity during dry summers when the Colorado trickled through the cliffs at a meager 200 cubic feet per second (cfs), yet withstand the terrifying onslaught of the river in flood, when 250,000 cfs could top the dam's crown by 16 feet. (Courtesy of the Lower Colorado River Authority.)

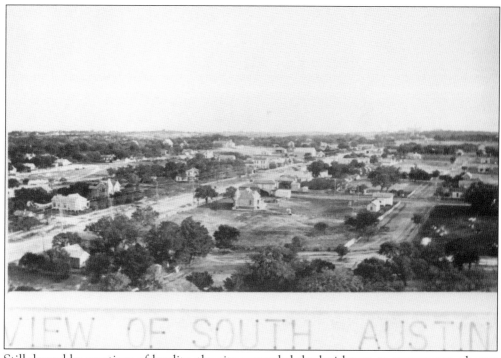

VIEW OF SOUTH AUSTIN

Still dogged by questions of legality, the city persuaded the legislature to approve two charter amendments. The first allowed Austin to operate its own utility, and the second approved the annexation over 20 miles of riverbank and the developing community of South Austin. Meanwhile, engineers led by Boston's Joseph Frizell began designing the future lake reservoir. To mark the desired crest of the lake, they cut a notch on a large pecan tree. Later, when the land was submerged, the lake level matched the notch perfectly.

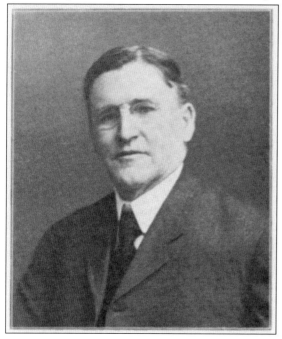

The contract for the construction was awarded to Bernard Corrigan, a politically influential building contractor from Kansas City. Best known for constructing that city's streetcar system, Corrigan and his firm now faced one of the greatest engineering challenges of the age. Corrigan's winning bid of $501,150 included excavating the site, constructing both faces of the dam, and completely filling it with rubble and mortar. All of the work would be done under the supervision of Frizell and his engineering team. (Courtesy of the Missouri Valley Special Collections, Kansas City Public Library.)

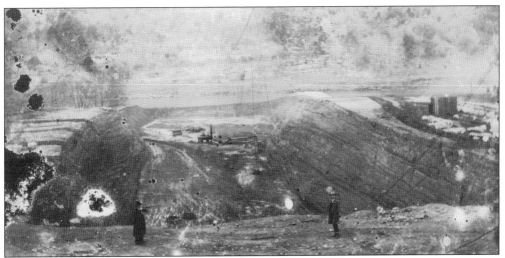

Investors failed to show much enthusiasm for the bonds the voters had so overwhelmingly authorized. To eastern capitalists, there was simply no upside to investing in a large water project in a place most of them had never heard of, being promoted by farmers and small-town businessmen who had no demonstrable knowledge of either dams or industry. In the end, a group of local leaders, including A.P. Wooldridge and George Brackenridge, assumed the financial risk themselves by buying $400,000 in bonds to start the project. With the seed money in hand, Corrigan began excavations on November 5, 1890.

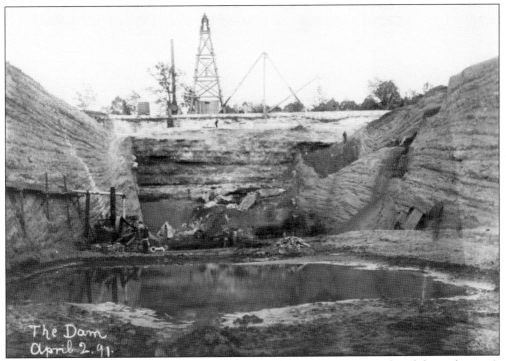

The winter of 1890–1891 saw the construction of a narrow-gauge railroad from the city's main rail depot at Pine Street (now Fifth Street) out to the damsite. The railroad would be used to ferry construction materials. The rail line followed the approximate route of today's Lake Austin Boulevard.

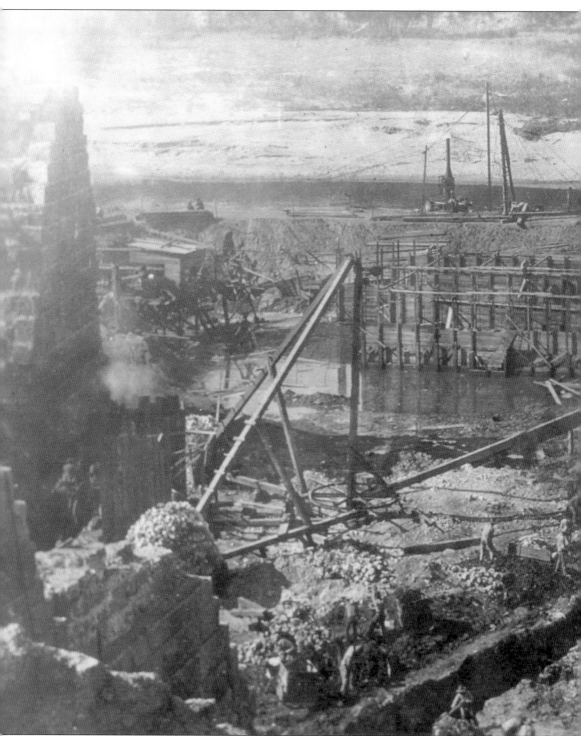

Within six months, crews had laid the groundwork for the project, including digging and blasting for the dam's foundation, building out the anchors on both sides of the river, and excavating a canal that would feed water into the powerhouse. On May 5, 1891, crews laid the first stone of

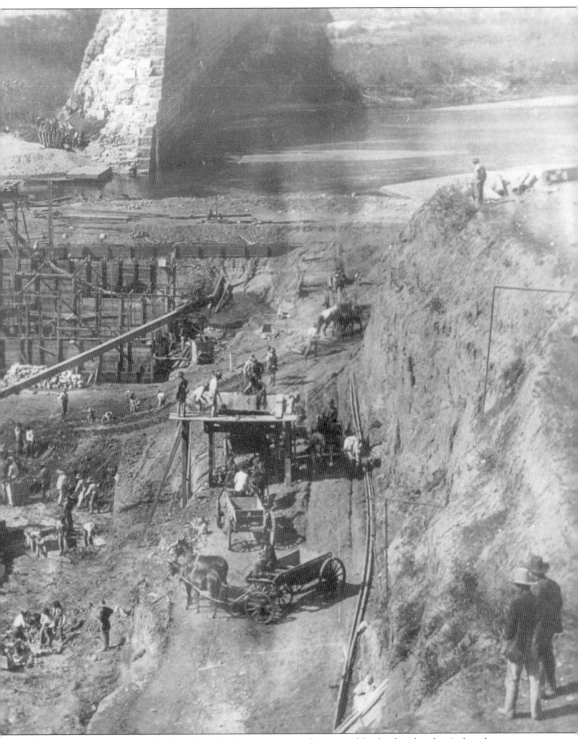

the foundation. In a mark of civil pride, huge sunset red granite blocks for the dam's facade were created for the project at the same Marble Falls quarry that had provided the granite for the state capitol.

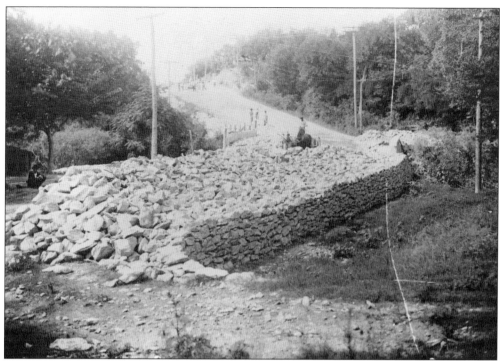

During the excavations at the damsite, the construction crew found numerous cracks and fissures in the limestone, along with sinkholes and layers of pulverized limestone. Essentially, no "bedrock" existed. As the holes were discovered, the crew filled them with cement and concrete and set aside the rubble to use later as filler for the dam.

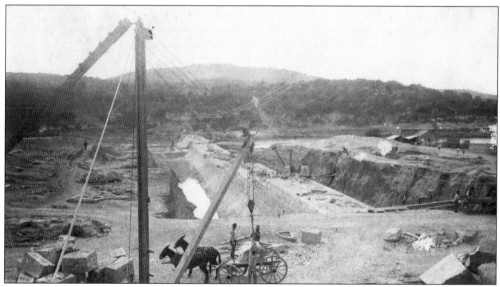

The enormous framework for the dam was protected on both sides by cofferdams (temporary earthen dams that kept the river water out of the construction site) that held the Colorado at bay. Few in Austin had seen a construction project of such magnitude. At that time, the Tredegar Iron Works complex in Richmond, Virginia, was the only large-scale industrial project of any size ever constructed in the American South.

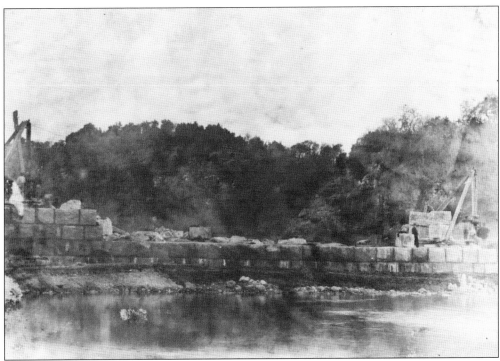

Austinites watched with pride as the two ends of the dam slowly began to grow toward one another. One of the most thrilling sights was to watch materials being maneuvered into place by a large, engine-driven cable strung between two towers on either side of the river. The cable was used to carry the enormous buckets of limestone rubble and cement that were dumped into the site. For each section, workers used massive tongs that gripped the five-ton granite blocks that were then set into both faces of the dam. On occasion, the chain cable broke, creating death-defying excitement.

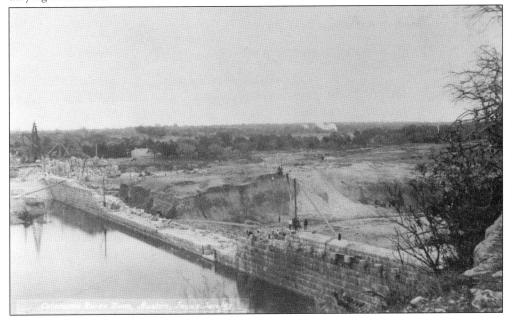

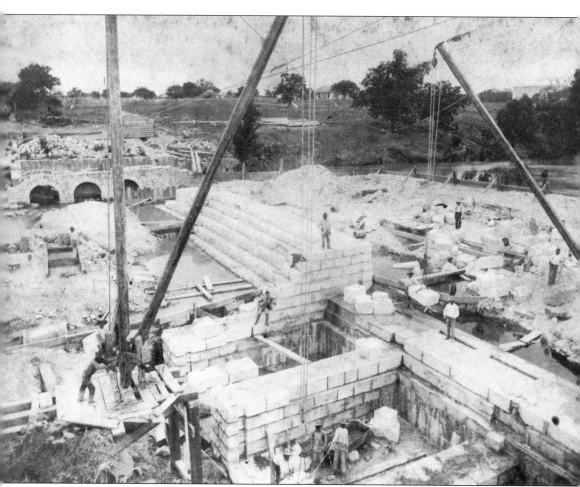

Thanks to the narrow-gauge railroad, the construction workers always had an audience picnicking at the damsite and sporting around the river on pleasure launches. According to the *Statesman*, "Every day hundreds go out, but on Sunday they turn themselves loose and flock to the place in droves in all manner of conveyances. The dam is their darling, and not a week must pass without their seeing what progress has been made since their last visit." Apparently, they were not above wandering through the actual construction site: "Mr. Corrigan especially requests visitors to keep off the masonry and from under the cable."

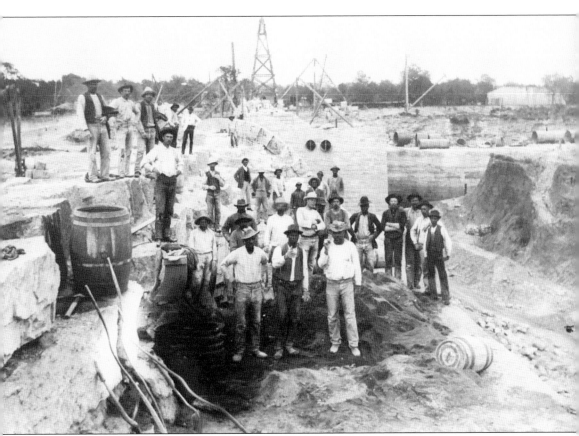

By April 1892, heavy spring floods caused the upstream cofferdam to collapse. In view of 300 spectators, workers scrambled for safety as a wall of water tore through the dam's west side and rushed into the construction site. Several huge granite blocks were washed 200 yards downstream. On May 26, members of a work crew repairing the damage was forced to run for their lives when three carts loaded with boulders plunged off the narrow-gauge railroad. The *Statesman* reported that the mishap was caused by "two small boys skylarking" on the tracks. (Courtesy of the Lower Colorado River Authority.)

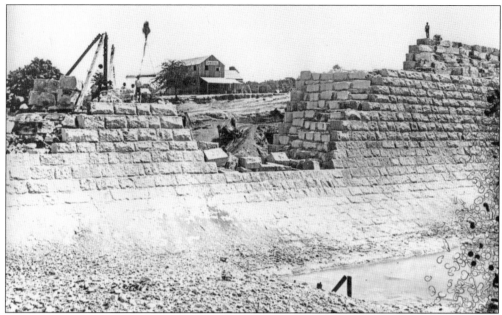

As the dam took shape, the reservoir began to fill in behind it, forming a lake some 27 miles long and as much as 75 feet deep. Originally called Lake Austin, it soon became known as "Lake McDonald" after the mayor who was doing so much to drive the project. Promotional materials promised that Austin was poised to become "the great 'Cotton Belt' of the great Southwest," and touted the dam to manufacturers looking for the perfect location to produce cotton, wool, and leather goods while enjoying "the most picturesque scenery in the South." (Below, courtesy of the Texas State Library and Archives Commission.)

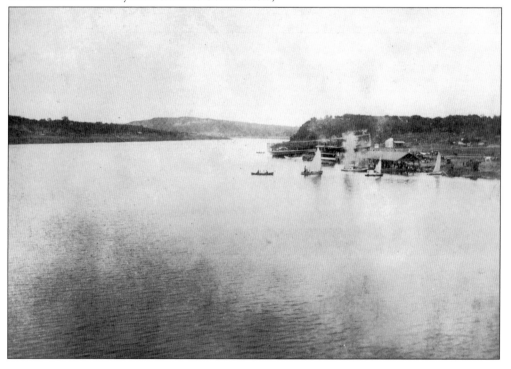

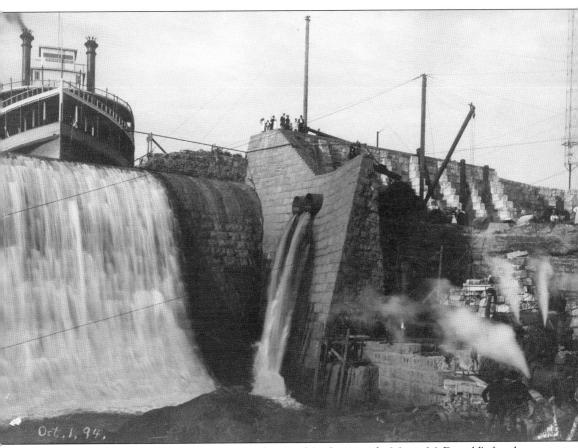

Oct. 1, 94.

The excursion boat *Ben Hur* looms over the dam in this photograph. Mayor McDonald's family had a financial interest in the boat, and lead engineer Frizell believed that the mayor and other city fathers had become less interested in hydroelectric power and more interested in developing Lake McDonald into a resort. Even as the troubled construction continued, boat docks, parks, and lakeside mansions began to take shape.

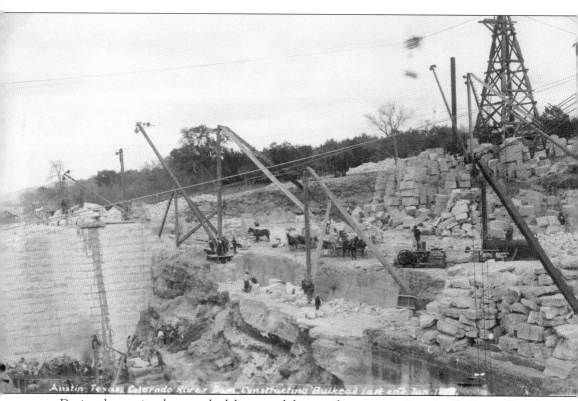

Austin Texas. Colorado River Dam. Constructing Bulkhead east end. Jan 18...

During the repairs, the crews had discovered that another, more ancient river had once flowed in the place of the present Colorado. This river had left behind loose soil and sediment to a depth of 40 feet, all of which had to be excavated and cleared away. On the east side of the dam, the limestone riverbed was unstable due to a 75-foot fracture, which the crews filled with clay. It was later understood that the dam had been constructed directly on the spot where the Colorado River crosses the Balcones Fault.

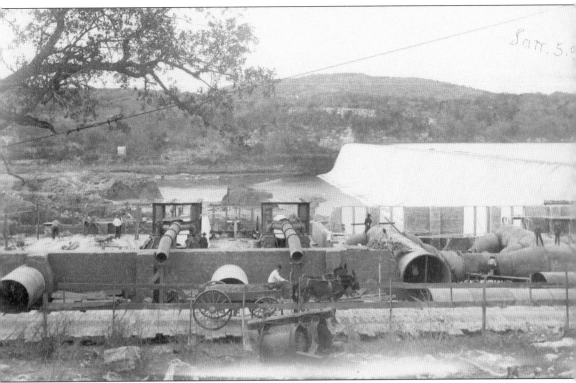

Mayor McDonald demanded major design changes to the dam, including relocating the powerhouse from the south side to the east side of the dam. Frizell protested the new, more complicated design. Instead of using the river's natural flow, water would need to be channeled into the powerhouse using huge sluice pipes (also called penstocks). Eventually, Frizell resigned along with several of his assistants, saying he was abandoning the project as he would "fire and pestilence." In later years, Frizell would accuse Corrigan of cutting corners on materials and the city of entrusting oversight of the project to officials with no knowledge of engineering.

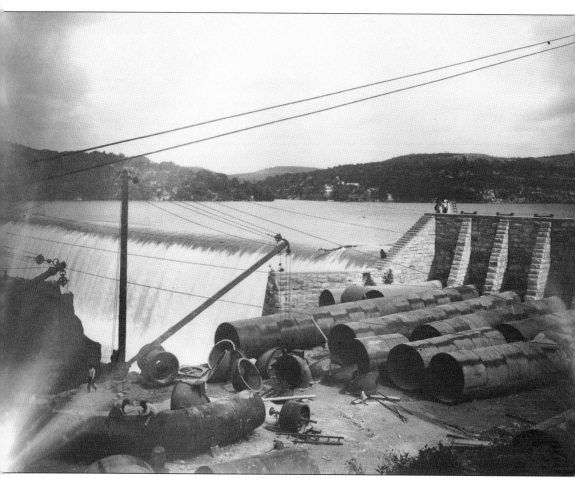

By September 1892, the installation of three large sluice pipes was only the most visible sign of the new powerhouse under construction. Two new contractors came on board to help complete the work. H.L. Breneman of Paris, Texas, was awarded the contract to build the powerhouse itself and install the 16 electrical dynamos purchased by the city. A local Austin partnership, Waterston and Wattinger, was hired to excavate and build the penstocks that would supply the waterpower. Best known as stonemasons, the partners were responsible for constructing not only the retaining walls for the water but also the complex system of gates, turbines, pumps, and pulleys needed to control it.

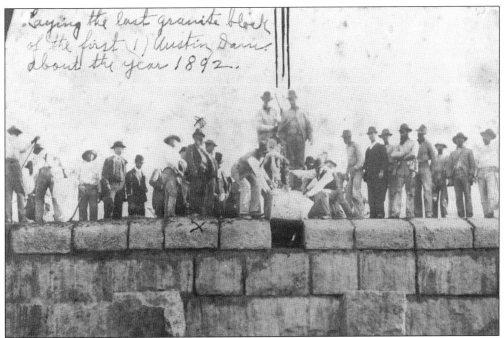

*Laying the last granite block of the first (1) Austin Dam about the year 1892.*

On May 4, 1893, some two years after construction had begun, Gov. James Hogg topped the list of dignitaries who gathered to dedicate the dam. At the time, it was the second-largest hydroelectric dam in the United States. It was also more than 20 percent over budget, with a final cost of $611,313.39. The extra cost was almost entirely due to the relocation of the powerhouse. The site chosen turned out to be comprised of loose boulders amid layers of pulverized limestone rather than solid rock, necessitating much more excavation than originally planned.

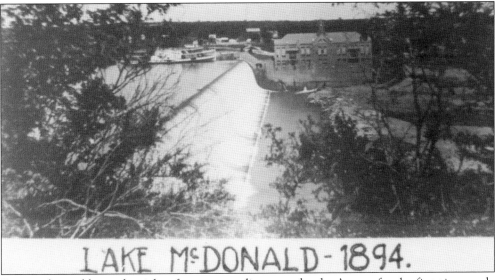

LAKE McDONALD - 1894.

Despite the problems, the sight of water cascading over the dam's crest for the first time made for a proud day for all concerned. As Austin businessman E.C. Bartholemew observed, "It is a magnificent structure. Whether or not it pays is another question." The *Statesman* was less gracious: "Austin's darling hope is now accomplished. Critics and back biters will please now go off and die."

A diver investigates the leaks under the foundation of the powerhouse, which began just two weeks after the dam's dedication. On May 30, the headgate masonry cracked, causing the powerhouse to flood and causing severe damage to the foundation and the penstocks. The repairs involved the construction of a new cofferdam and a redesign of the entire east side of the dam. This work involved an additional 38 feet of excavation to reach bedrock, the reconstruction of the powerhouse, and the building of a tunnel to channel the river under the headgates. To deal with the powerhouse leaks, engineers created a 10-inch drain, nicknamed "the spring." The repairs took 17 months and added $97,000 on to the cost of the project.

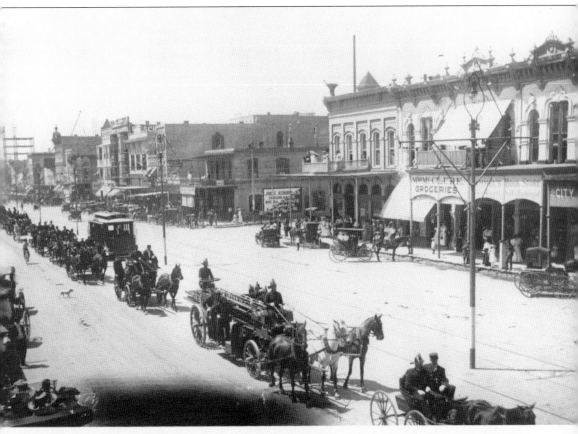

CA 00284, Austin History Center, Austin Public Library

On March 7, 1895, the pumps at the "Great Granite Dam" began to turn once more, touching off a giant celebration in Austin. The next task would be replacing the mule-drawn streetcars with electric models and building out the water and power system to connect the city's homes, stores, schools, offices, government buildings, and hotels. Soon, kerosene lamps and hand-pumped water would be a thing of the past. The city planned to offer service for 60 hours a week, storing the flow on nights and Sundays to allow for heavier use at peak times.

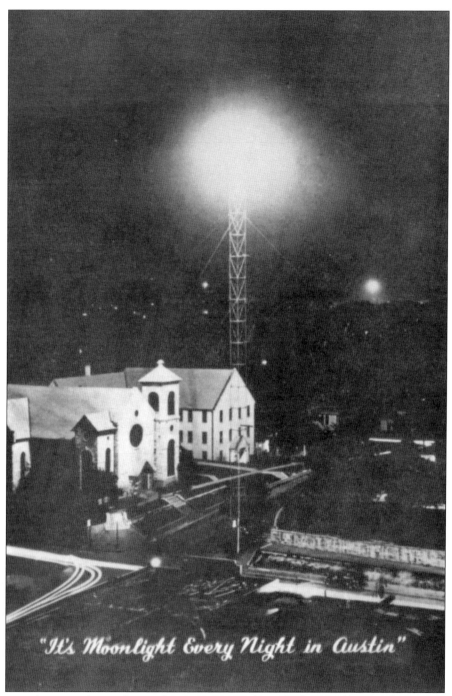

"It's Moonlight Every Night in Austin"

The most dramatic change for residents came at night with the installation of 31 "moonlight towers," which bathed the city streets in the luminous glow of carbon-arc lamps. Seventeen of the towers still stand, the only examples remaining in the world. In addition to driving away the night, the dam enabled Austin to embrace modern firefighting technology. Voters authorized $200,000 in bond money for the moonlight towers and a complete system of fire hydrants, valves and hoses, and utility vaults (commonly called manholes).

# *Three*

# Austin in the Dam Era

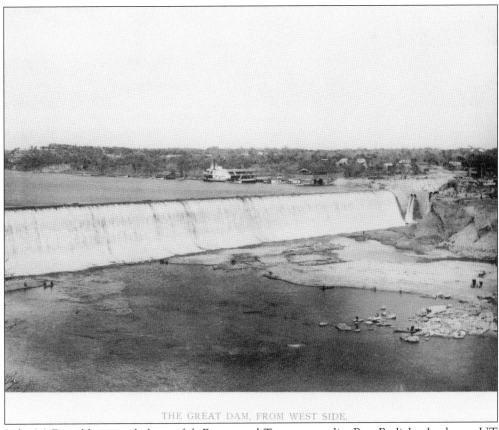

THE GREAT DAM, FROM WEST SIDE.

Lake McDonald was truly beautiful. Renowned Texas naturalist Roy Bedicheck, then a UT student, would remember, "Never before had I seen so much water in one place. Here in Austin was a river not like the mud-bound Brazos but one of clear water tumbling over a dam out of a dark blue lake."

The genteel lifestyle at Lake McDonald embodied the best of the Gay Nineties. The rail line that once carried spectators to the construction site became an electrified streetcar line to the lake. It was a magnet for canoeing, sailing, and rowing. For families, there was a baseball diamond and a small zoo with Texas wildlife, located near the site of the present Hula Hut restaurant.

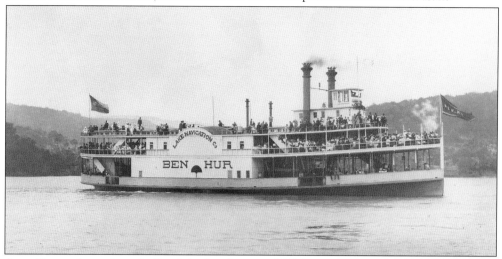

A pavilion and grandstand offered the first "respectable" dance venue in Austin, where couples could dance to traditional German oompah tunes and popular new songs such as "Hot Time in the Old Town Tonight," and "Bicycle Built for Two." Below the dam, Bulian's Beer Garden was a favorite watering hole for university students and a popular choice for military reunions.

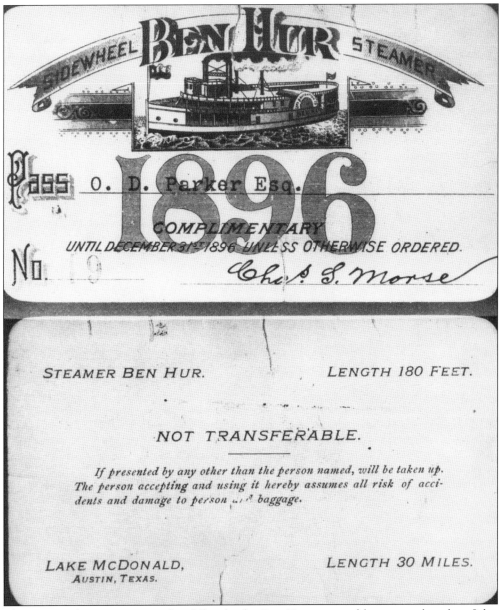

SIDEWHEEL **BEN HUR** STEAMER

Pass   O. D. Parker Esq.

1896

COMPLIMENTARY

UNTIL DECEMBER 31ST 1896 UNLESS OTHERWISE ORDERED.

No.    Chas. S. Morse

STEAMER BEN HUR.                    LENGTH 180 FEET.

NOT TRANSFERABLE.

*If presented by any other than the person named, will be taken up.*
*The person accepting and using it hereby assumes all risk of acci-*
*dents and damage to person and baggage.*

LAKE McDONALD,                    LENGTH 30 MILES.
AUSTIN, TEXAS.

The spectacular steam-powered paddle wheeler *Ben Hur*, operated by none other than John McDonald (the mayor's son), was three stories tall, held 2,000 revelers, and featured a vaudeville stage on its deck with minstrel shows, song-and-dance acts, comedy routines, and touring musicals.

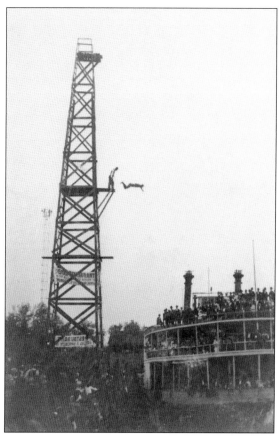

Lake McDonald was Austin's own venue for a nationwide trend towards modern entertainment for the masses, including traveling circuses, rodeo shows, acrobat acts, and daredevil stunts of all kinds. Divers regularly performed acrobatics from a derrick-like tower near the boathouse. On any given day, the entertainment over the lake might include hot-air balloons, fireworks, or colorful illuminations of the water cascading over the dam. In 1898, the famed "lady aerialist" Hazel Keyes thrilled Austinites when she slid across the entire lake from a cable suspended from the summit of Mount Bonnell—with the assistance of her pet monkey, Yan-Yan.

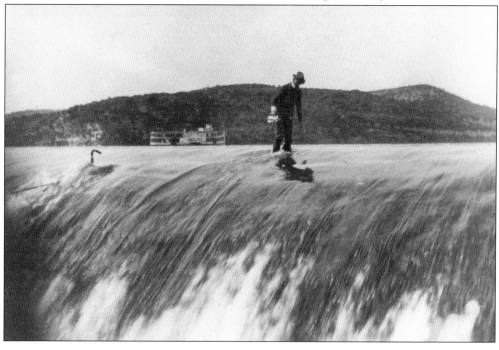

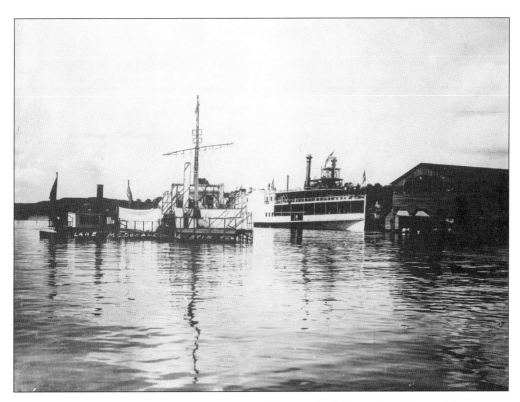

Those looking for a more sedate experience could cruise the lake on the 500-seat *Chautauqua*, the 70-seat *Telephone*, and at least five other smaller excursion boats. The boats frequently took parties to the Chautauqua grounds (under present-day Lake Austin in the vicinity of Emma Long Park) for picnics and fish fries, or to Camp Mabry for military reenactments. Austin also hosted several rowing regattas that attracted international competition and thousands of spectators. In 1895, James Stanbury of Australia set a world record for sculling on the lake, leading to publicity for the lake as "the finest race course in the United States" and the city as a "health and pleasure resort."

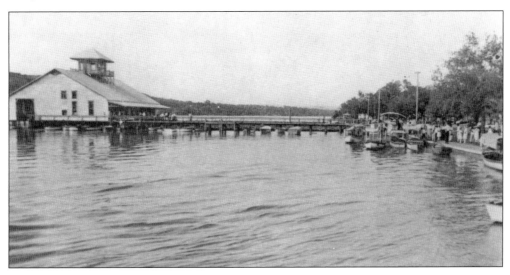

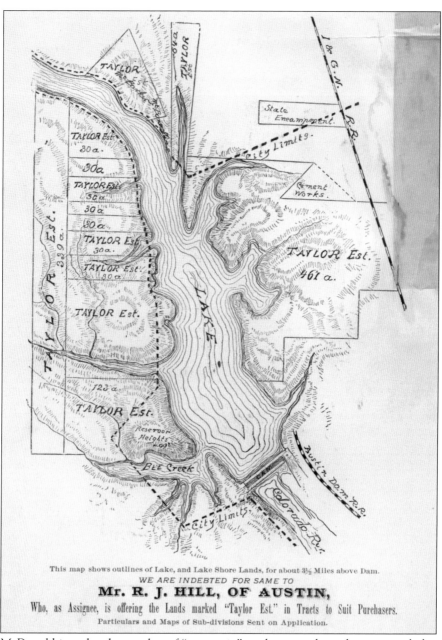

This map shows outlines of Lake, and Lake Shore Lands, for about 3½ Miles above Dam.

*WE ARE INDEBTED FOR SAME TO*

**Mr. R. J. HILL, OF AUSTIN,**

Who, as Assignee, is offering the Lands marked "Taylor Est." in Tracts to Suit Purchasers.

Particulars and Maps of Sub-divisions Sent on Application.

Lake McDonald inundated a number of "mountain" settlements along the river, including Bee Springs, Mormon Springs, Mount Bonnell Springs, and Santa Monica Springs, once a Native American campground. But as power lines were strung from poles all over town, such losses seemed small. During the dam's heyday, property values in Austin rose from $9 million to $12 million. *Engineering Magazine* quoted a consultant as saying that Austin was well-positioned to become the center for processing the natural resources of Texas—such as coal, copper, lead, and silver—in "almost inexhaustible abundance." Another engineer commented, "When Austin grows up to its water power, it will be a big place indeed," and the *Statesman* rhapsodized, "What we must have is one large airy modern hotel adorning these uplifted projecting cliffs and crags . . . no Alhambra of old Granada ever equaled it." (Courtesy of the Texas State Library and Archives Commission.)

The lake was not the only area booming with real estate speculation. North of Austin, a new development called Hyde Park offered a genteel lifestyle on a site formerly used as a racetrack and fairgrounds. Hyde Park was Austin's first streetcar suburb, served by an electric line that ran north from Sixth and Congress along the Old Georgetown Road (now Guadalupe).

Elisabet Ney, the celebrated sculptor, was one of the first to build in Hyde Park. Her castle-like studio, Formosa, was soon joined by upscale Victorian mansions and more modest bungalows. "Miss Ney" was not the only eccentric genius to make Austin home. William Sidney Porter—better known by his pen name, O. Henry—worked by day at the General Land Office and, by night, created the cartoons and short stories that would make him famous.

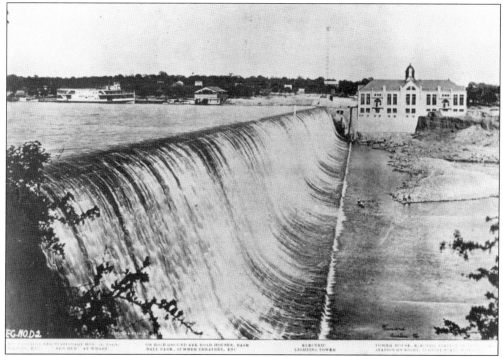

The dam and its lake began to put Austin on the map as a destination. Long feature articles in the *New York Times*, the *New York Herald*, and *Harper's Weekly* predicted Austin's future as the "modern Athens" with a dam "securely anchored to the solid rock of the hills on either side of the river." Developers sold hundreds of lots around the lake for what later generations would have called a "planned community" of resort cottages.

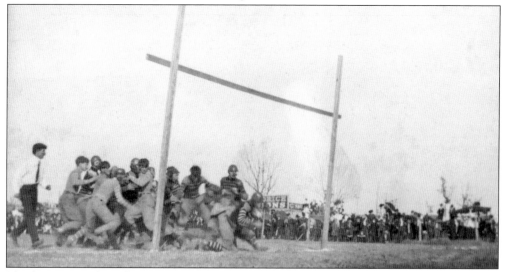

The decisions made in the 1890s would shape Austin's future in countless ways. The University of Texas began to sponsor an official student football club in 1895. Not yet known as the Longhorns, the team wore gold-and-white uniforms and played at the Varsity Athletic Field at Twenty-Fourth and Speedway Streets, at the present site of the Gates Computer Science Complex. (Courtesy of the Dolph Briscoe Center for American History.)

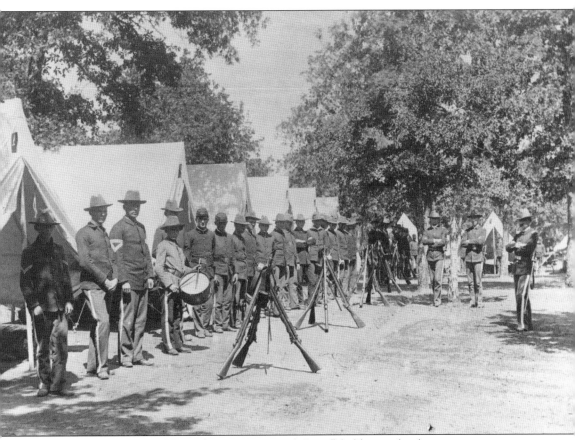

The Texas Volunteer Guard (later the Texas National Guard) held annual military encampments in the Hyde Park area for decades. During those years, the volunteer guard's duties included patrolling the border with Mexico, combating cattle rustling, providing disaster relief, and guarding jails to prevent lynchings.

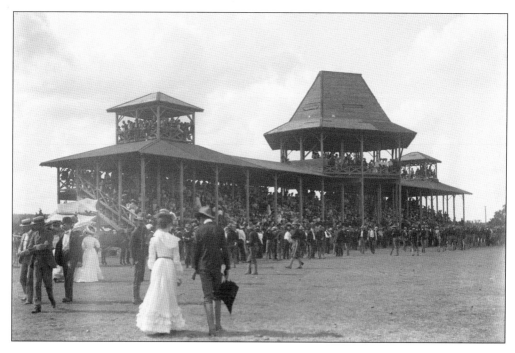

In 1892, the City of Austin donated an 85-acre site overlooking the Colorado to secure the summer militia encampment on a permanent basis. A grandstand was built for those spectators wishing to view drills and battle reenactments. In 1898, Camp Mabry became a mobilization center for the Spanish-American War. A total of 38 of Texas's 48 guard companies served in the conflict, doing duty in Cuba and the Philippines. The camp also became a weather station that year, a distinction it still holds. Greatly enlarged, Camp Mabry served as a training camp through two world wars as well as a training camp for the Texas Rangers, and continues to serve as the Texas state armory and headquarters of the Texas National Guard.

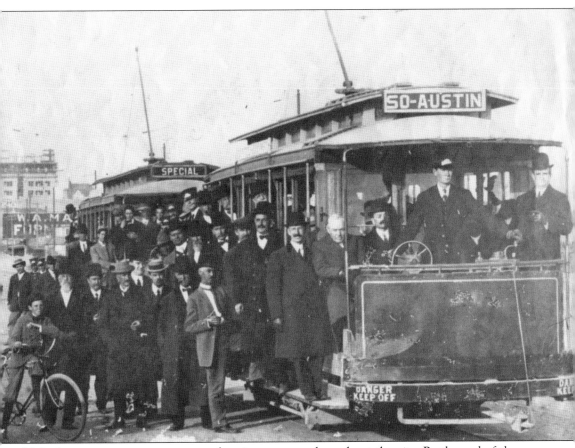

Mule-drawn streetcars gave way to electric streetcars throughout the city. By the end of the decade, Austin was served by 15 miles of electrified lines, which were often out of commission due to problems with the power plant at the dam. On one occasion, the tracks washed out in a heavy rainstorm, stranding people who had been attending a concert in Hyde Park. The streetcar company hired horse-drawn carriages to pick up the passengers, charging surge prices of six dollars ($162 in today's currency) to take a party of four back to town.

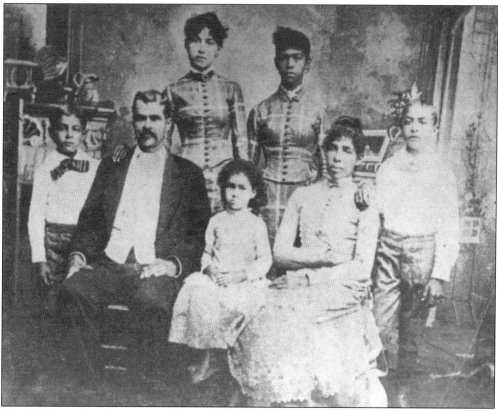

The African American population of Austin grew by 61 percent in the 1890s. Many of the new residents were fleeing the establishment of harsh Jim Crow laws in East Texas. At that time, black Austinites lived in at least 13 different neighborhoods around town, including former "freedom towns" such as Clarksville and Wheatville. These photographs depict Frank Strain and his family and their home on Speedway. Strain, a former railroad porter, was a janitor at an Austin school. (Both, courtesy of the Jacob Fontaine Religious Museum.)

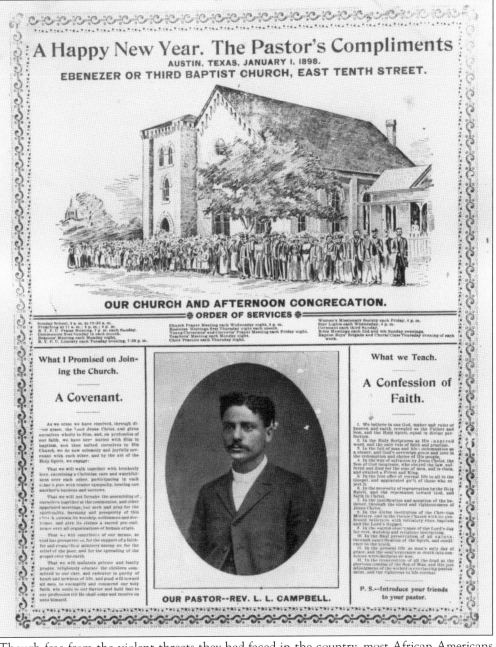

## A Happy New Year. The Pastor's Compliments

AUSTIN, TEXAS, JANUARY 1, 1898.

### EBENEZER OR THIRD BAPTIST CHURCH, EAST TENTH STREET.

**OUR CHURCH AND AFTERNOON CONGREGATION.**

**OUR PASTOR--REV. L. L. CAMPBELL.**

Though free from the violent threats they had faced in the country, most African Americans faced hardship, working as laborers or domestic servants and often living in shacks or tents and hauling water from nearby creeks. Many frequently went back to their rural roots in the spring to help put in the crops. Churches, schools, and black-owned businesses united the community, which was led by Lee Lewis Campbell, the pastor of Ebenezer Baptist Church and publisher of the *Austin Herald* newspaper. (Courtesy of the Jacob Fontaine Religious Museum.)

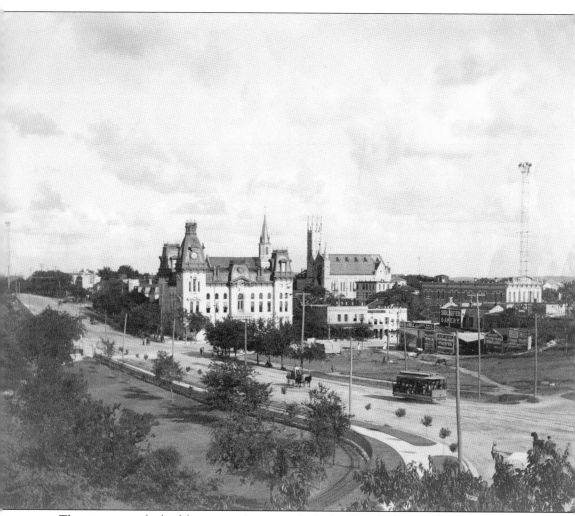

The picturesque look of downtown Austin masked a hard truth. A year after the dam began full operation, the *Statesman* boasted that all the city needed was "four dozen more big smokestacks" to complete the project. But in fact, not a single manufacturer ever expressed interest in locating to Austin, which remained a residential city dominated by the state government and the university. The 1900 census described the population of Austin as 12,800 white, 6,000 black, 3,200 of Mexican descent, and 22 Chinese.

# Four

# "THE GREAT MISCALCULATION"

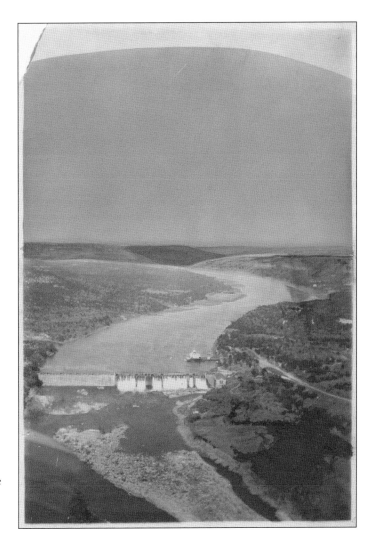

Despite its enormous size, the dam failed to generate anything approaching the 14,000 horsepower that had been anticipated. In May 1896, the level of Lake McDonald fell too low to go over the dam's crest and through the headgates. The low lake levels occurred twice more in 1896 and five times in 1897, including the entire month of December.

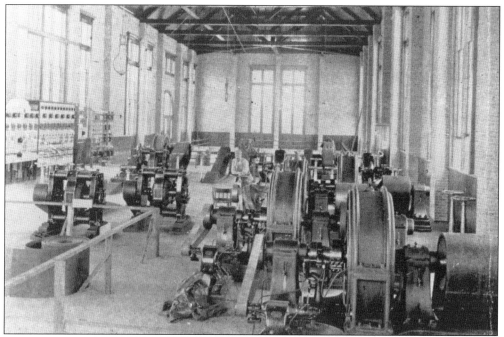

During low lake levels, the powerhouse (interior shown here) operated at a mere 900 horsepower—not enough to keep the moonlight towers and electric streetcars operational, much less supply the needs of homes and businesses. In addition to technical issues, the dam project was plagued by lawsuits from the private utility Austin Water, Power, & Light (AWPL). AWPL alleged that the project had been funded illegally, as state law prohibited public money from being spent to benefit private enterprise. The uncertainty caused the city's bond rating to fall.

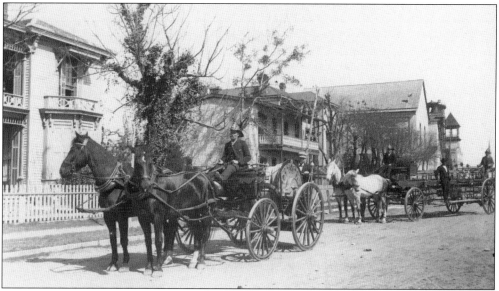

The lawsuits did not endear AWPL to the public, which had long been fed up with the utility's high rates and unreliable service. The "city dew plant," as some wags nicknamed AWPL, was so inadequate that Austinites were often forced to rely on cisterns or haul water from the river and found themselves with dry fire hydrants in the higher parts of town.

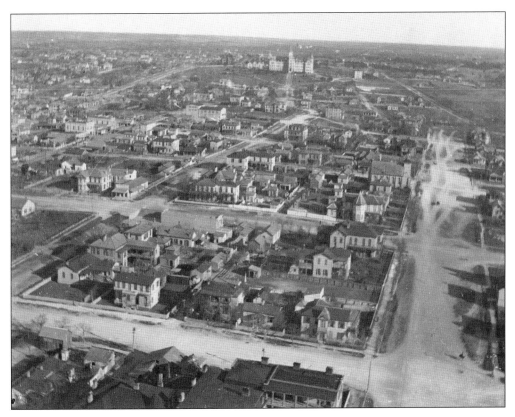

When the dam was working, the city's rates for water and electricity were a bargain—half the price charged by AWPL. A small house with only one faucet was charged just 50¢ per month (about $14 in today's currency), while a large house paid $1.50. Electrical rates were competitive with kerosene at 25¢ per lamp. The city took in more revenue from hotels, which paid $50 a month. Institutions such as the University of Texas, seen here in a c. 1898 view from the capitol, were charged between $100 and $500. (Above, courtesy of the Texas State Library and Archives Commission.)

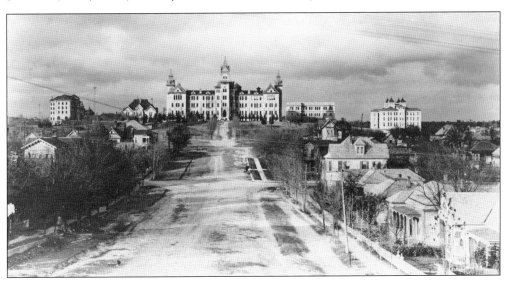

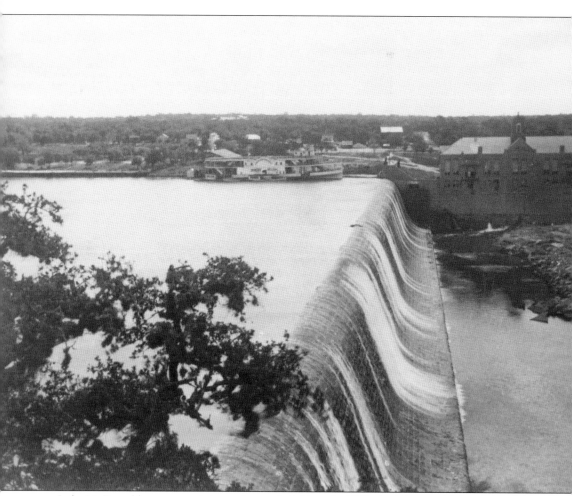

Lake McDonald was not only low—it was shrinking. In 1893, the lake was 80 feet deep and held 83.5 million cubic yards of water. Just four years later, so much silt had been deposited that the lake was only 50 feet deep and held 51.8 million cubic yards. At 14 miles above the dam, the water level had dropped from 20 feet to just 5.5 feet. The resulting low flow over the dam is clearly visible in this photograph.

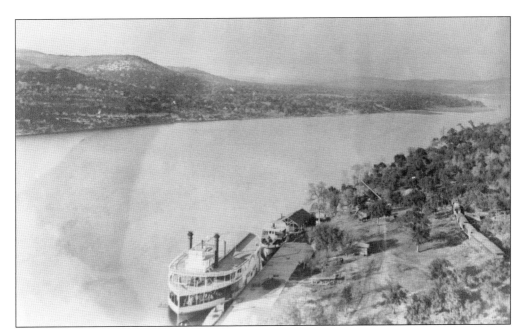

At such levels, the *Ben Hur* could no longer operate. Anyone wishing to hold their event on the paddle wheeler had to be content with the view from the "floating palace" now staked at the mouth of Bee Creek above the dam. During the dry months of the year, resort homes and businesses lay stranded 75 feet from Lake McDonald's muddy banks. Instead of living the high life, Austin's taxpayers would be servicing an enormous bond debt for the foreseeable future, with little to show for it. The dam was, as one observer put it, "a stupendous fraud."

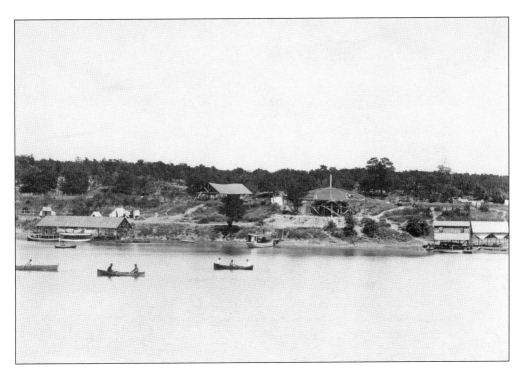

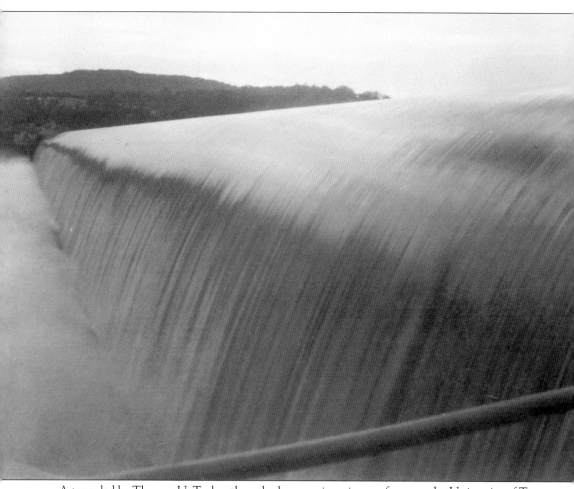

A team led by Thomas U. Taylor, then the lone engineering professor at the University of Texas, found that the silting stemmed from the sluggish flow of the Colorado through Austin. In 1890, boosters had forecast a minimum flow of 1,000 cfs, which yielded the projected 14,000 horsepower for the dam. The entire project was designed and built based on the 1,000 cfs figure.

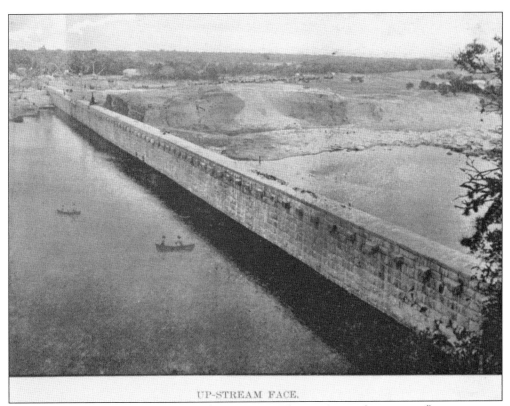

UP-STREAM FACE.

Unfortunately, the estimates were grossly inaccurate. The river's actual minimum flow was a mere 200 cfs. Moreover, thanks to the design changes ordered by former mayor McDonald, the dam lacked the capacity to store floodwaters during periods of heavy rain. Excess water simply rolled over the crest and continued downstream to the gulf.

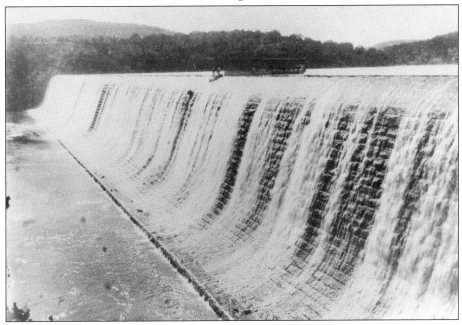

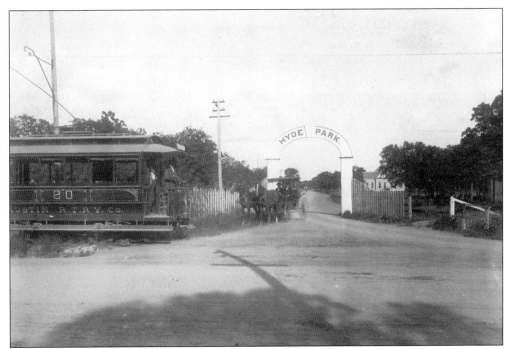

As Taylor noted, accurate measurements could have been obtained at the beginning of the project for "one-tenth of one percent of the outlay for the construction of the dam." Now, it was too late. The great Austin dam would never do more than supply the city with water and light—provided Austin did not grow. The promised factories, with their thousands of jobs and the revenue that would develop Austin's streets and parks, were never coming. The quality of life was also impacted. Without sufficient water pressure, what came out of city pipes was frequently stagnant and foul.

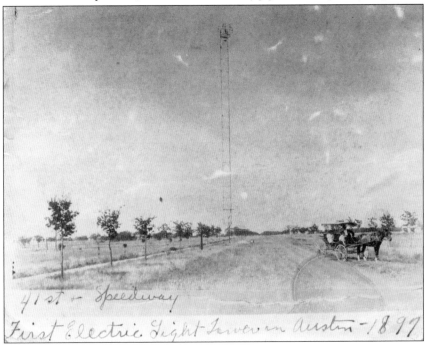

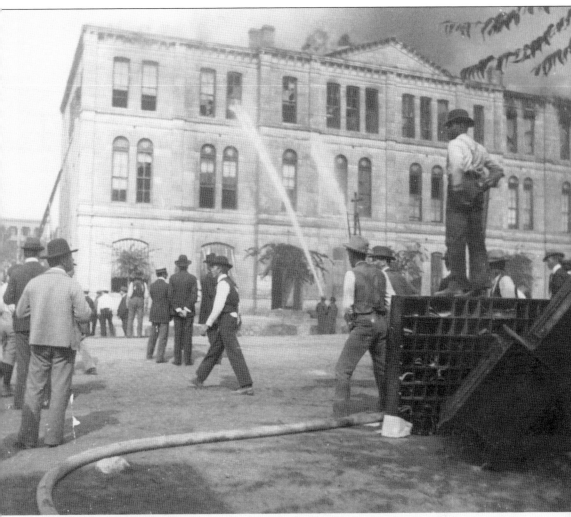

Since 1882, a handsome three-story brick building had anchored the corner of Congress Avenue and Eleventh Street. Used as a temporary capitol building from 1882 to 1888, during the construction of the grand Texas State Capitol, it had, in more recent years, been used as an office building and for classroom space for Austin High School and the University of Texas Law School. On September 30, 1899, the old temporary capitol caught fire. As had become commonplace, the dam was nonfunctional due to low water, and AWPL was unable to supply firefighters with sufficient water pressure to battle the blaze. The building was destroyed. Enterprising Austinites incorporated the bricks into new buildings around town, several of which still exist. The building's foundation is preserved as a small public park.

In 1898, the dam was out of operation several times, including the entire period from October until April of the following year. In 1899, it was out of commission a total of 191 days. The moonlight towers went dark, and power was cut to the entire city except for the businesses along Congress Avenue, where the streetcar tracks were under construction. For the time being, Austin's streetcars traveled only by mule power. The city began looking for a way out. There was talk of putting the dam up for sale and using the proceeds to build a modern steam power plant.

By mid-1899, Lake McDonald stood at 52 percent of capacity, with the remainder filled with silt. But there were bigger problems. The dam had begun to leak. In the spring of 1899, city workers used bags of clay to plug a persistent leak near the powerhouse. By the fall, the dam's symptoms had become alarming. The land in front of the powerhouse was noticeably sinking, along with the area between the powerhouse and the penstock gates. City crews found that two of the penstocks had buckled, along with one of the discharge pipes. The city brought in wagonloads of earth and hay to shore up the dam's east end and installed several new pipes to channel leaks away from the dam.

# Five

# THE DAY THE DAM BURST

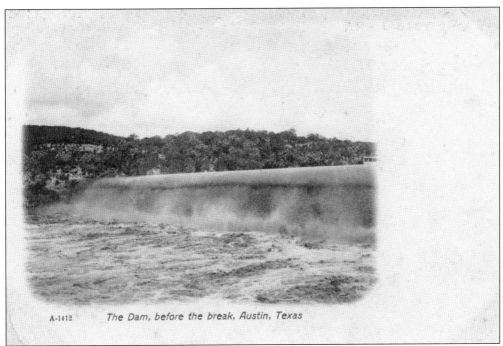

A-1412    The Dam, before the break, Austin, Texas

On Thursday, April 5, 1900, hot, sultry spring weather in Val Verde County, in the Rio Grande Valley near Del Rio, gave rise to a line of spring storms full of lightning, gusty winds, and torrential rain. Even as the storms drifted northeast toward Central Texas, a second powerful, slow-moving storm had formed in the High Plains over Swisher County near Amarillo and began to move to the southeast. It was Mother Nature's setup for a classic Hill Country flash flood.

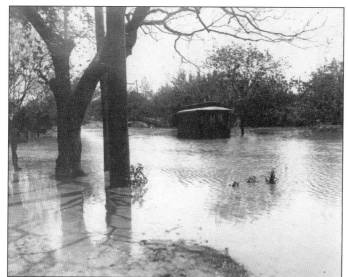

Austin had already had an unusually wet spring, and the thin soil was saturated. When the two weather systems converged over Travis County, they created a rainmaker such as had not been seen for many years. Over a 48-hour period, the massive storm hammered Austin with some 17 inches of heavy rain.

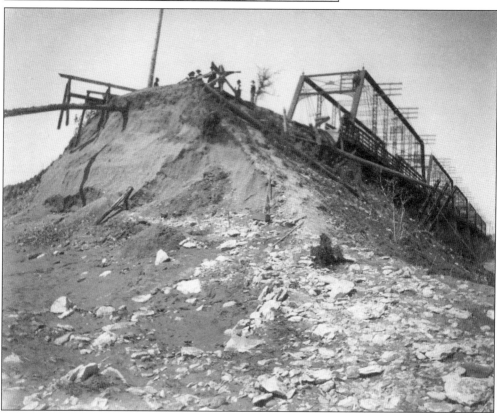

At 4:00 p.m. on Friday, the Cannonball Express—an International & Great Northern train that provided service from St. Louis, Missouri, south through Texas—attempted to cross a flooded railroad bridge near McNeil, about nine miles north of town. The bridge washed out, and the engine and five cars plunged into the floodwaters. Fortunately, no lives were lost. The narrow-gauge Austin & Northwestern Railroad, best known for bringing the red granite for the construction of the capitol and the dam, lost five bridges in the storm.

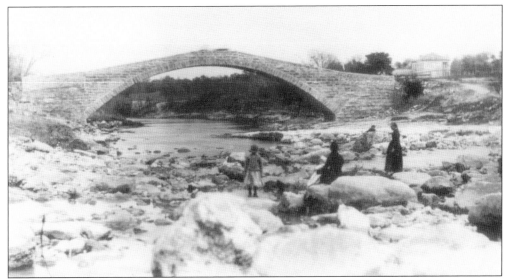

In the overnight hours of April 6–7, Shoal Creek overflowed its banks and washed away the homes and barns of several impoverished families. The 1871 rock bridge across Barton Creek, near the site of today's pool, was smashed to pieces, as were smaller wagon bridges throughout the area.

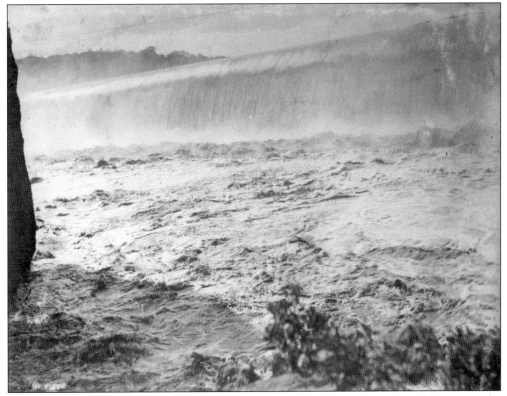

Around dawn on Saturday, April 7, the rain began to slack off, revealing a horrifying site at the dam. The full force of the flooded Colorado was barreling downstream. The river had risen 40 feet in just 10 hours. The dam itself was topped by an 11-foot sheet of water churning with downed trees and wreckage from Hill Country flooding.

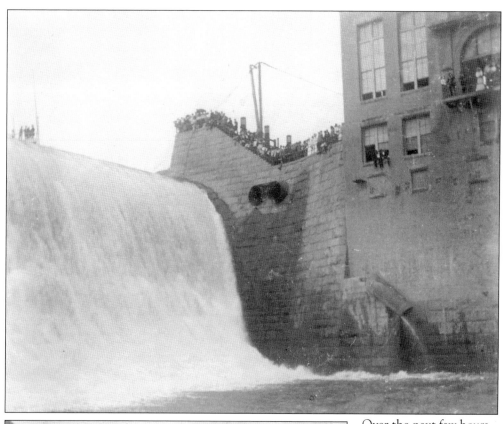

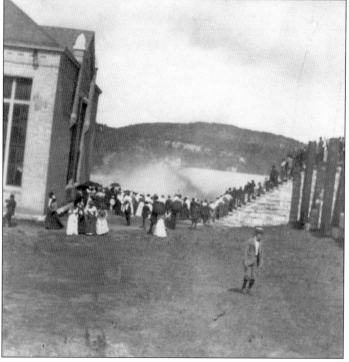

Over the next few hours, a crowd of about 500, many of them university students, gathered to marvel at the spectacle. Inside the powerhouse, a crew of workmen and day laborers under engineer Frank Pinget was hard at work pumping out floodwaters so that water and power service to the city could be restored. Also on hand were three children, the sons of workman Walter Johnson and a friend who had come along for the adventure.

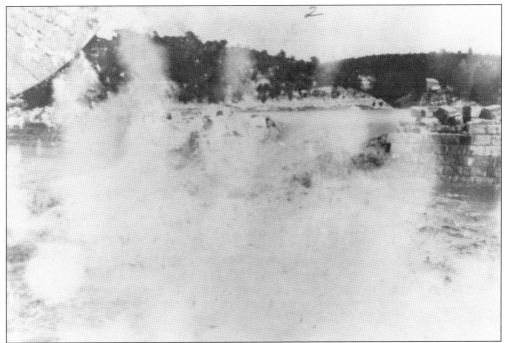

Eighteen-year-old Alfred Townes Carleton, later a Houston attorney, was an eyewitness to what happened next: "I remember very vividly, though it were but yesterday, watching a large tree floating down the river. Just as it reached the crest of the dam, a great boulder buckled upward as if some great power had forced the huge blocks toward the sky. . . . Then the force of the water rushing through the break tossed the blocks of stone down the river as if they were merely slips of wood." These photographs capture the moment the dam burst. The time was 11:15 a.m.

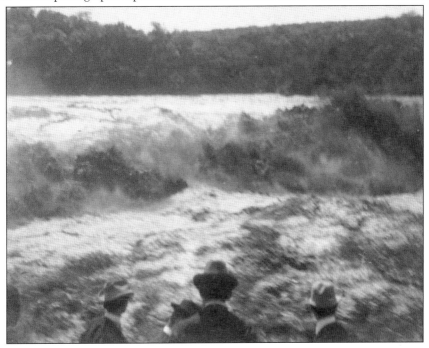

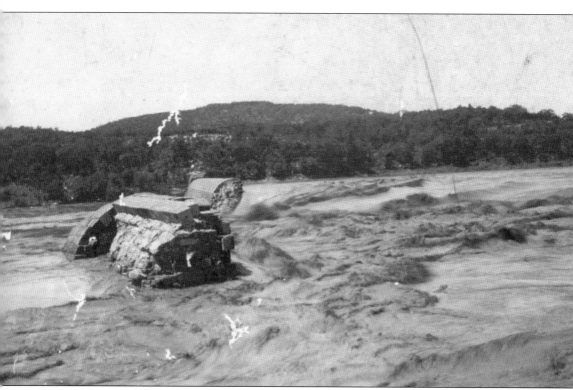

The earth shook, and with a deafening roar that could be heard for miles, two of the enormous granite blocks on the east side of the dam's facade exploded forward in a surge that carried them 60 feet downstream in a matter of seconds. The entirety of Lake McDonald, roiling with debris and with the full force of the Colorado behind it, came barreling through the gap. One witness recalled that the spectators ran for their lives in "the wildest alarm . . . like a bed of red ants that was suddenly disturbed."

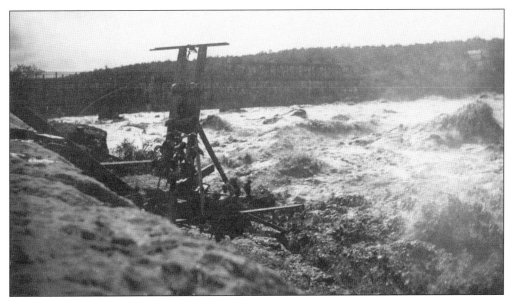

No one present ever forgot the screams of the men trapped inside the powerhouse as it was engulfed by a wall of water some 50 feet high. Miraculously, two men swam to safety through the holes in the floor where the pumping equipment had been installed. Of those trapped inside—five men and the three young boys—the *Statesman* noted that they "were drowned like rats."

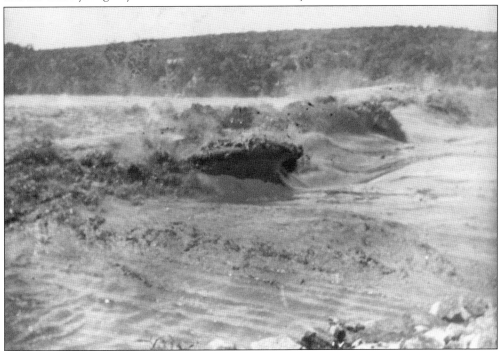

During Lake McDonald's decline as a recreation spot, a small community of about eight families had erected a campground below the dam. Thought to be of Italian descent, they fished and lived off the land. Their makeshift housing was obliterated in an instant and at least three men were killed. Along both sides of the river, houses with all of their contents, along with horses, cows, and dogs, all became part of the tide of debris crashing downstream.

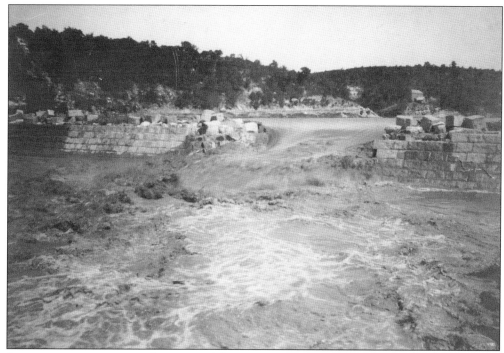

Spectators were swept into the torrent. Most were rescued or managed to save themselves, but two men, along with a woman and her two children, were drowned before anyone could come to their aid. Twenty-one-year-old Lee Watts, who worked at the pumping station but was outside the powerhouse when the wave hit, said that the water took everything in its path. He added, "We had been told it might happen some day. But when it did, there was nothing to be done about it."

Witness Henry Robell, identified by the *Statesman* as a "laboring man," had the presence of mind to jump on his horse and gallop into town, shouting the alarm that the dam had burst. Robell's cries saved the lives of hundreds of people who had gathered on the Congress Avenue bridge to marvel at the floodwaters. As they fled, a wall of water and debris swept over the bridge, though the structure survived. One of the spectators on the bridge was seven-year-old Tom Miller, who was destined to leave his own lasting mark on the saga of Austin and the Colorado River.

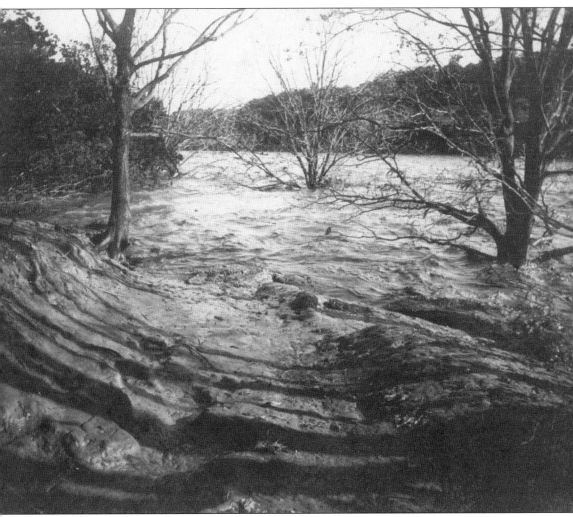

Robell reached downtown Austin within three minutes of the dam's collapse. O.D. Parker, manager of the Western Union telegraph office, immediately acted to relay the news to offices downstream. With no mass communications, the warnings came too late for many as the Colorado rampaged into the valley south of Austin. It was later estimated that the Colorado was a mile wide and 60 feet deep as it barreled south. Dozens of houses and barns and hundreds of head of livestock were claimed by the waters, along with thousands of acres of cotton, corn, and produce.

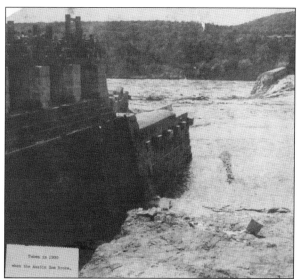

Student Laurence Ledbetter, later superintendent of the capitol grounds, had celebrated his 18th birthday the night before. He later recalled that the discussion centered around the rainstorm and rumors that the dam could break. Like many others who were in town that morning, Ledbetter witnessed clouds of steam and smoke rising from the direction of the dam as the water took out the powerhouse. Rushing to the scene, he saw a tide of reddish water pouring through the broken dam along with numberless trees and houses from upstream.

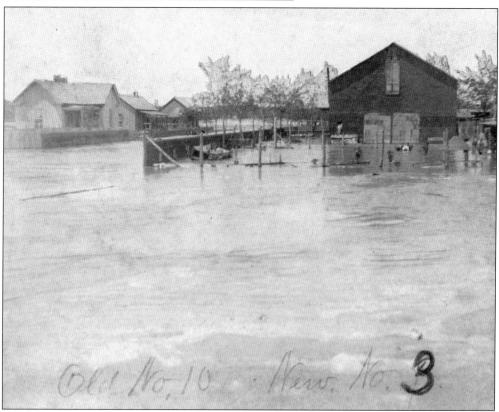

Ozwin LaFrance, sometimes identified as Claude Franklin, had taken advantage of the break in the rain to go buy medicine for his wife, Nora. Trapped on a flooding bridge as he returned home, LaFrance managed to escape as his horse and buggy were swept away. LaFrance clung to a utility pole, but before onlookers could come to his aid, a frame house crashed into the pole and threw the man to his death. His body was recovered nine days later in a pile of debris near Webberville, a dozen miles downstream.

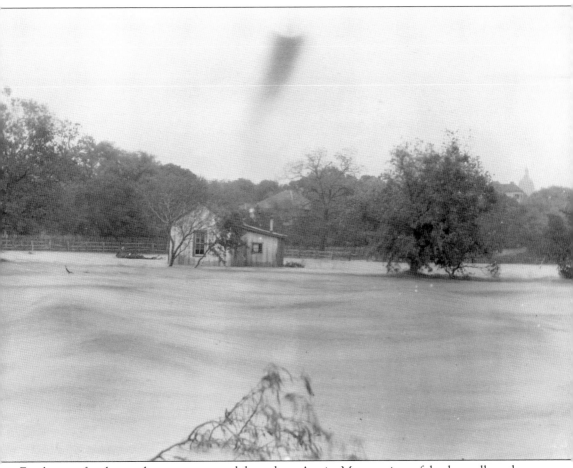

For the next four hours, the water rampaged throughout Austin. More sections of the dam collapsed and tumbled into the river. A family of four who lived along Waller Creek were swept to their deaths. Along Barton Creek, families scrambled to safety on rooftops and trees. Not until about 3:00 p.m. did the river begin to recede, revealing its awful toll.

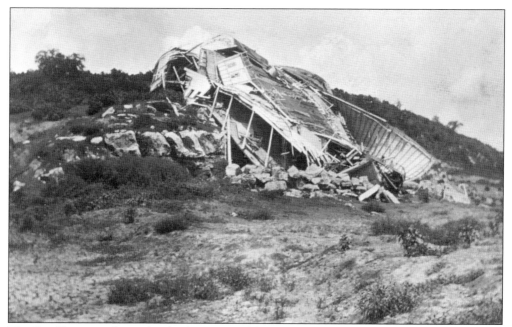

The *Ben Hur*, once the pride of Lake McDonald, was gone, along with all of the other pleasure boats. As the *Austin Tribune* recorded, "not a vestige of the lake" remained. At least 100 homes had been destroyed. The riverfront was impassable, with floodwaters extending from Barton Springs Road and East First along Waller Creek to Red River and Neches. The south approach to the Congress Avenue Bridge had washed out, leaving South Austin isolated. Even the dam's archrival, the "old waterworks" of AWPL, was inundated with 15 feet of water and destroyed.

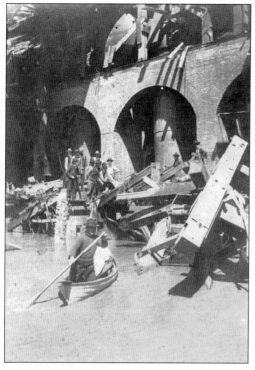

That terrible day, the city was paralyzed by the magnitude of the disaster. As the *Statesman* noted, "Strong men, who had faced death a thousand times, when shot and shells swept the air, hurried down the street with tears streaming down their cheeks, and really knew not where they were going." In the coming days, massive downstream flooding caused damage in the millions all the way to the gulf as the river stormed through Travis, Bastrop, Fayette, Colorado, Wharton, and Matagorda Counties. Several more lives were lost, though most residents had enough warning to escape to higher ground with their livestock.

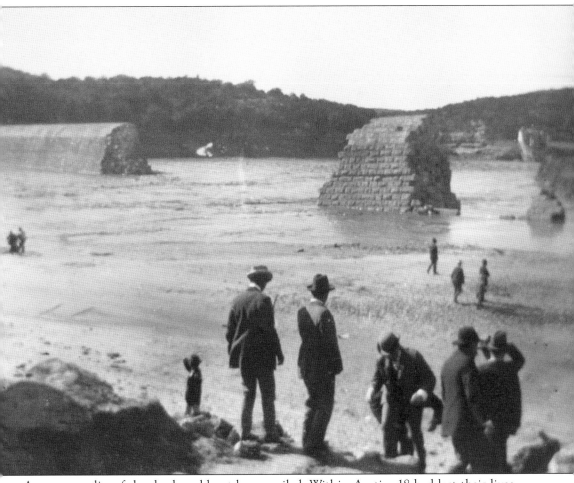

An accurate list of the dead could not be compiled. Within Austin, 18 had lost their lives, including 8 in the powerhouse disaster. At least 32 were killed downstream. Upstream, as the *Statesman* noted, "The loss in the mountain regions [Hill Country] is equally as great judging from the number of houses and household furniture drifting by all day." Many of the dead were poor folks who had lived along the river and its creeks, leaving little to no trace in the written records of the time. One man's name was recorded simply as "Old Dan."

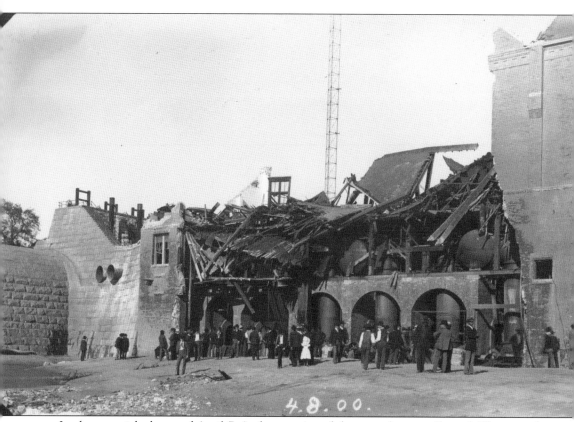

In the overnight hours of April 7–8, the remains of the powerhouse collapsed. The next day, the grim work began of recovering the bodies began. In an eerie echo of the dam's construction, thousands gathered to watch the "grewsome" sight. As Lee Watts recalled, "We had no equipment to cover the dead. We worked for 27 straight hours with anything we could get our hands on." Under the direction of Austin firefighters, all able-bodied men not otherwise affected by the disaster were put to work clearing the rubble.

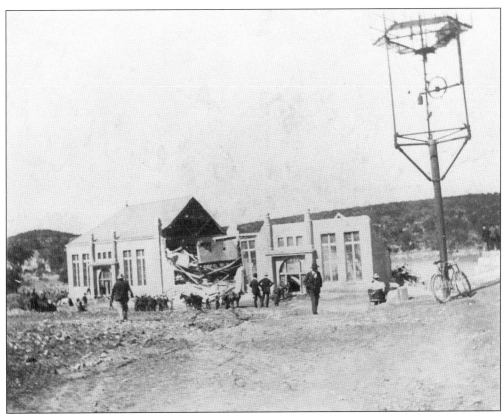

As the funerals began and the waters receded, the long-term effects of the disaster slowly came into focus. The city was without water or electricity. It was September before the streetcars resumed operation. By January, the city had completed a sheet-iron barn that housed several dynamos to supply electricity to Congress Avenue, the capitol, and the city-county hospital (located on the site of modern-day Brackenridge Hospital), and the moonlight towers once again shed light over the humbled city. (Courtesy of the Lower Colorado River Authority.)

To provide for clean drinking water, the city tapped a freshwater spring at Tenth Street and Congress Avenue, where water could be hauled away from a trough. To guard against fire, the fire department filled all of the city's cisterns, and the cities of Houston and Waco sent additional equipment. In a decision that left Austinites deeply divided, the city arrived at a settlement to buy AWPL and operate it as a public utility. The price tag was over $700,000—some $21 million today. (Courtesy of the Texas State Library and Archives Commission.)

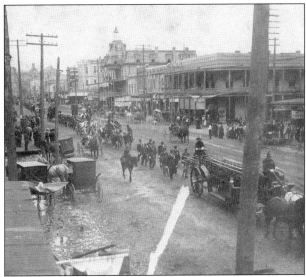

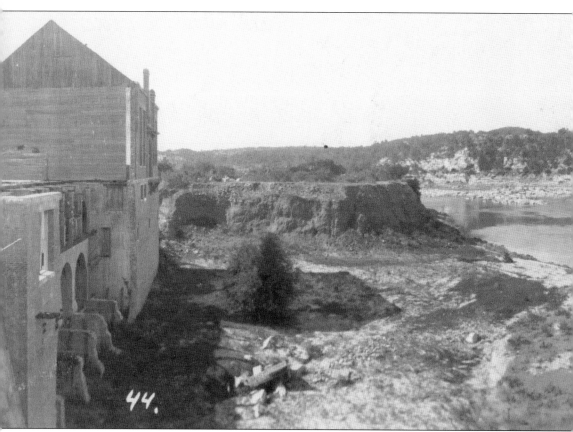

In the long term, the hardest blow was the loss of the dam itself and the future it had embodied. In the wake of the disaster, property values in Austin tumbled 29 percent. Moreover, the city still owed $1.3 million on the bonded indebtedness it had incurred to construct the dam. Most of these bonds had passed into the hands of eastern bondholders, who expected to be paid regardless of

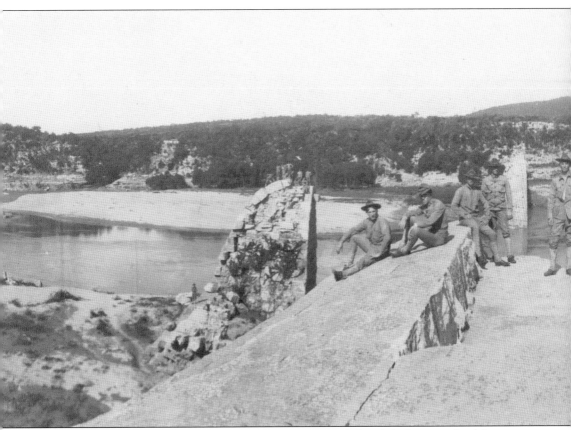

the fact that the dam no longer existed. For a time, it appeared that defaulting on the debt was the only answer. In 1901, New York bankers agreed to restructure the city's debt. The long-lost dam would be a burden on the shoulders of Austin taxpayers until 1931. (Courtesy of the Lower Colorado River Authority.)

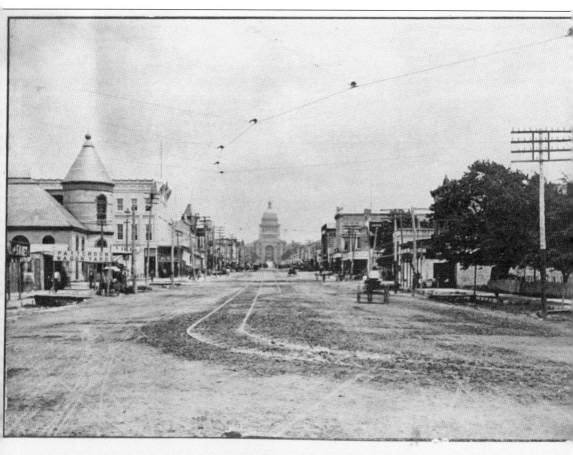

CONGRESS AVENUE, LOOKING NORTH.

Many years later, the *Statesman* interviewed elderly survivors of that fateful day. For them, it was a tale of innocence lost: "The old Austin of O. Henry being led off to Huntsville handcuffed to a thief, of Roy Bedicheck as a student on the cactus-clumped Forty Acres, of Shoal Creek as the timeless boundary between town and country, and of the Main Line street car was never the same again." (Courtesy of the Texas State Library and Archives Commission.)

*Six*

# THE AFTERMATH

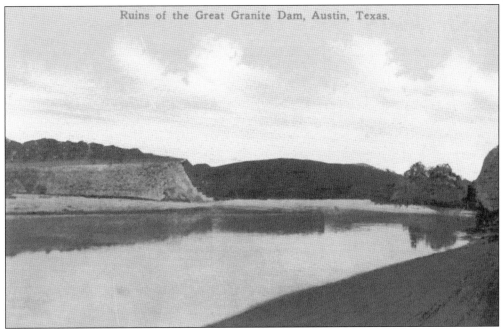

Ruins of the Great Granite Dam, Austin, Texas.

The dam disaster was, in the words of one observer, "a numbing and stunning blow" that haunted the city for decades. The first step was to understand what had happened. Thomas U. Taylor, the University of Texas (UT) engineering professor, prepared a study for the US Geological Survey that fixed the blame on three causes: the original design as based on a flawed understanding of the flow of the Colorado, the engineering changes made by the city during construction, and the lack of understanding of the geology of the area. (Courtesy of the Lower Colorado River Authority.)

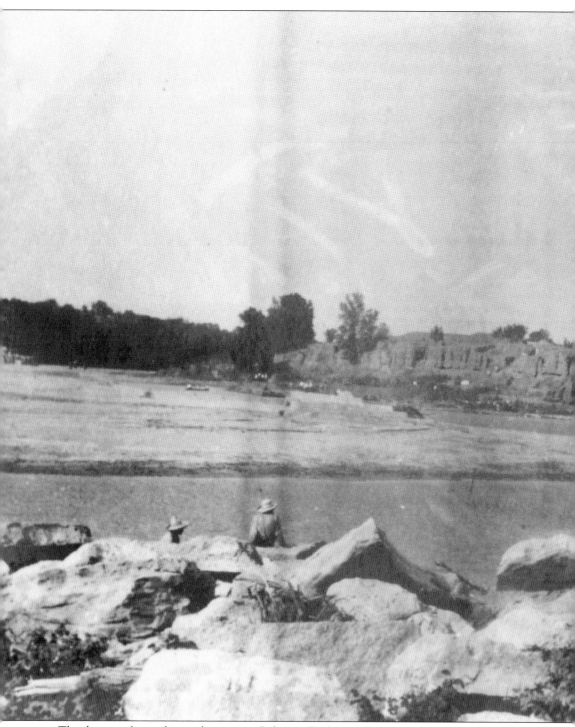

The dam was located atop the ancient Balcones Fault on a limestone formation that was prone to clay seams and voids. Taylor reported that the leaks and cracks that developed under the dam's

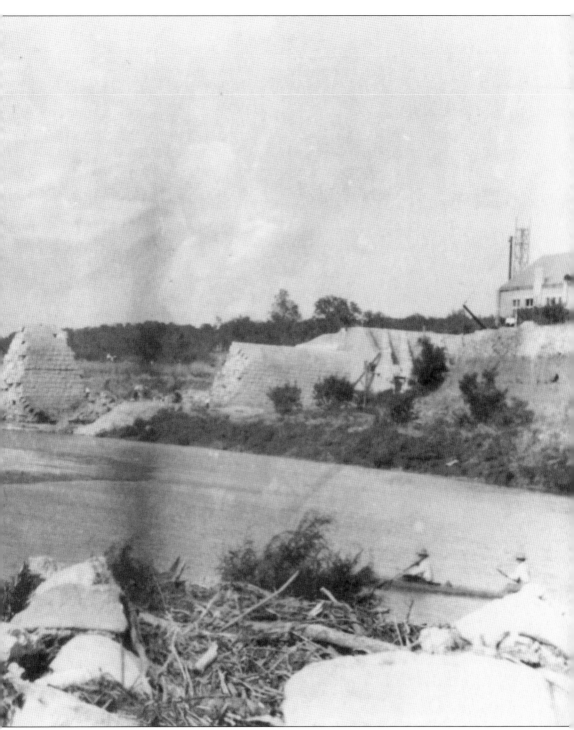

east side during its construction and afterwards were poorly understood and improperly repaired. It was this area that gave way in the 1900 flood.

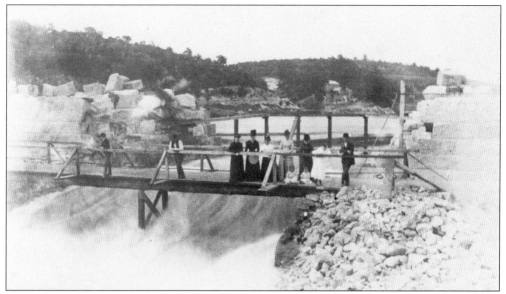

The original project engineer had resigned over the city's demand that the powerhouse be relocated from the south side to the east side of the dam. Taylor determined that the powerhouse draft tubes had discharged against the base of the dam on the downstream side, gradually undermining the structure from below.

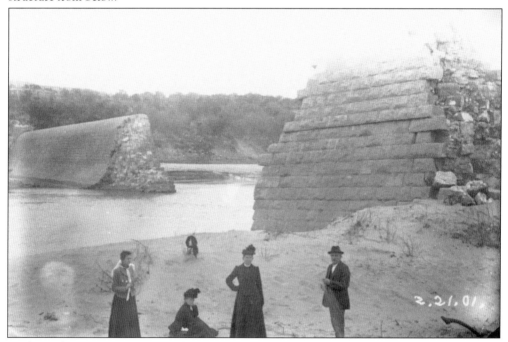

Studying the construction of the dam's remains, Taylor determined that the cement rubble core of the dam was "first-class," but that the granite facing was improperly constructed. Neither debris from the flood nor the silting up of Lake McDonald played a significant role in the dam's failure. In fact, if the lake had been at full capacity, the magnitude of the disaster would have been even worse. It took two days for Lake McDonald to completely empty out into the downstream flow of the river.

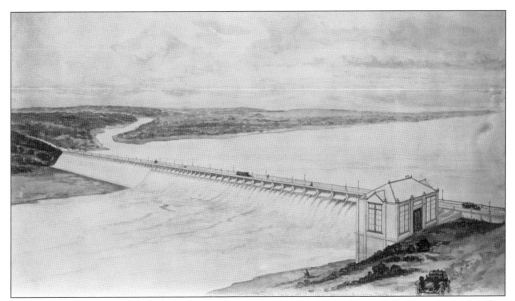

In 1905, Taylor worked with a Boston consulting engineer, George C. Evans, to develop recommendations on building a new dam for Austin. The Army Corps of Engineers recommended against rebuilding at the same site, and several locations were discussed, including upstream near the present site of Max Starcke Dam in Marble Falls. However, the final plan called for building on the same spot, incorporating the remains of the western portion of the old dam and scavenging materials from the wreck of the powerhouse as a cost-saving measure. The city undertook extensive preparation, including a feasibility study conducted by a board of experts led by the US Reclamation Service.

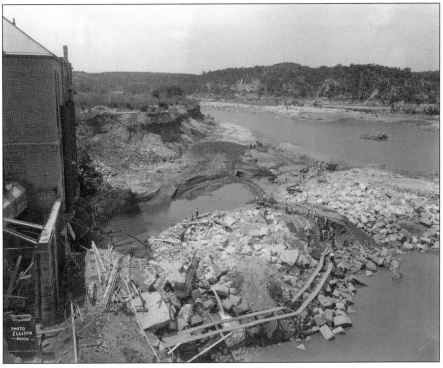

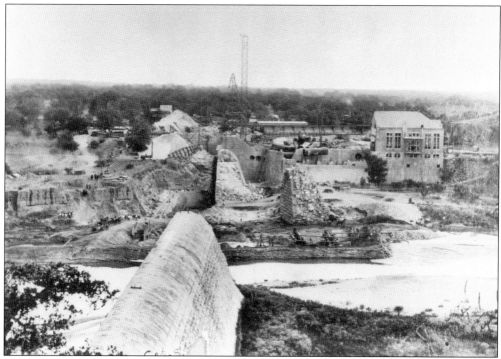

In 1911, Austin voters authorized a bond issue to pay for a new dam that would provide both hydroelectric power and flood control. After several false starts, the city awarded a contract for $25.5 million to William D. Johnson of Hartford, Connecticut. The new dam would differ from the old in several significant ways, including the use of floodgates, reinforced steel construction in both the dam and powerhouse, and an innovative installation of the turbines in reinforced concrete chambers. The power would be transmitted by aluminum cable to a city steam plant three miles away. (Above, courtesy of the Lower Colorado River Authority; below, courtesy of the Texas State Library and Archives Commission.)

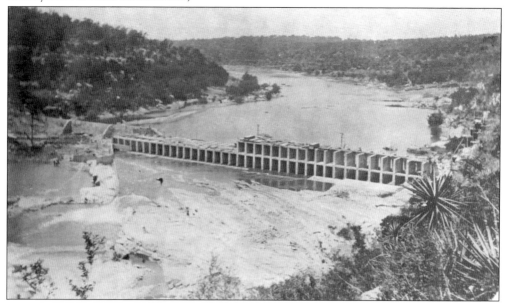

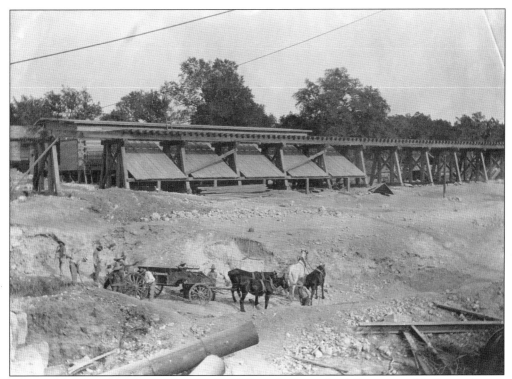

In 1912, Johnson sublet the contract to the William P. Carmichael Company of St. Louis. Austin boosters began to talk of building a road across the dam and a hotel on the lake, but it was not to be. From the beginning, the project was troubled. Digging the foundation to a suitable depth to prevent the sliding that destroyed the first dam proved more costly than first thought. Crews forced tons of grout into all of the limestone seams to solidify the foundation. The Colorado flooded 20 times during the construction, killing 49 people in total and causing numerous project delays. (Below, courtesy of the Lower Colorado River Authority.)

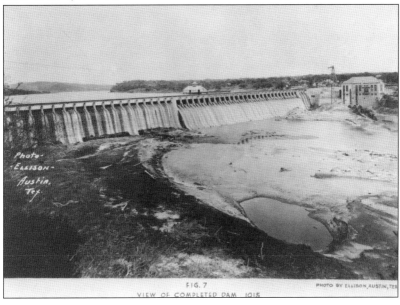

FIG. 7
VIEW OF COMPLETED DAM 1015

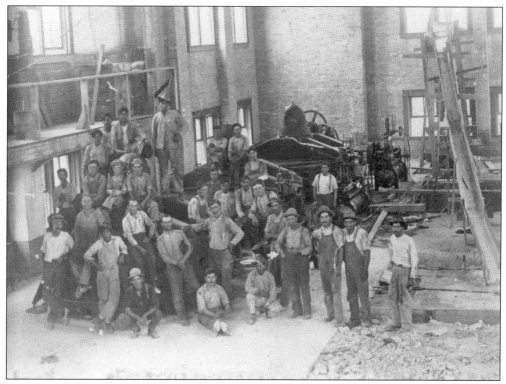

Tragedy had taken the edge off Austin's ambitions. City fathers now touted Austin as the center of government, education, and gracious living in Texas. Limited in growth, the city tumbled in size to tenth place among Texas cities. The small tax base meant that funds were limited for amenities such as parks, trash collection, animal control, sewers, and paved streets. Once again, it was the civic vision of A.P. Wooldridge, elected mayor in 1909, that infused the city with renewed energy for civic planning and modernization. But the dam continued to haunt Wooldridge's dreams. (Both, courtesy of the Lower Colorado River Authority.)

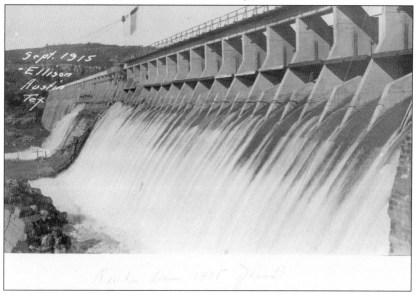

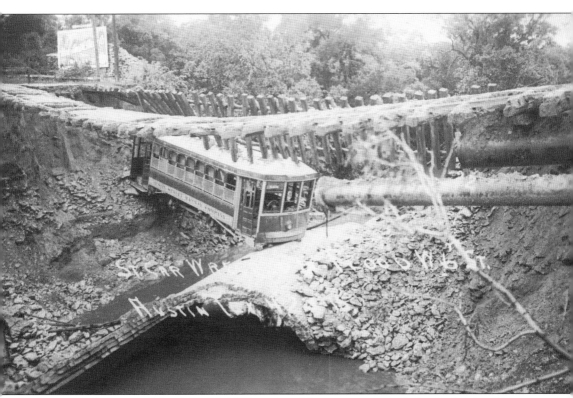

In the overnight hours of April 22–23, 1915, a powerful spring storm stalled over Austin. The intensity of the rain event—some 10 inches in only three hours—was the most severe in memory. Shoal Creek and Waller Creek raged out of their banks, catching many unawares. Thirty-two people in the city were killed, and 1,000 people were left homeless. Miles of streetcar tracks were destroyed.

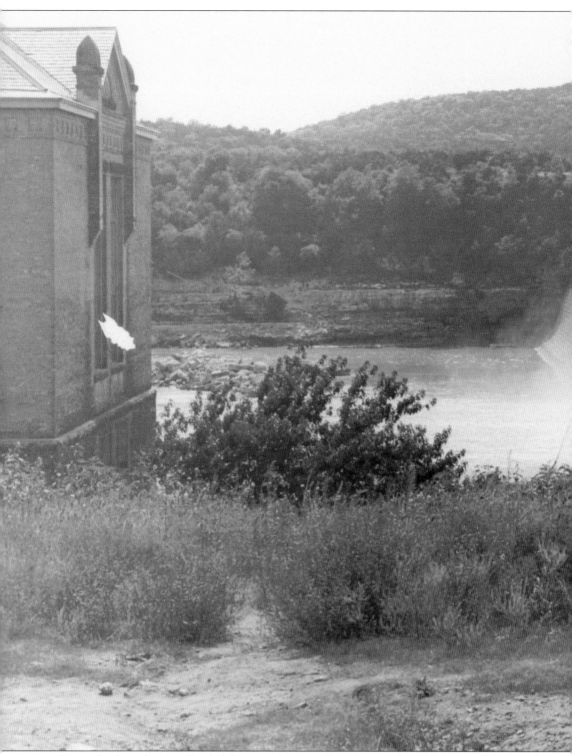

Out at the dam, the river flooded the powerhouse with rocks, gravel, and debris, and the wooden floodgates of the dam were wrecked. Repairs were under way when a second flood hit in September.

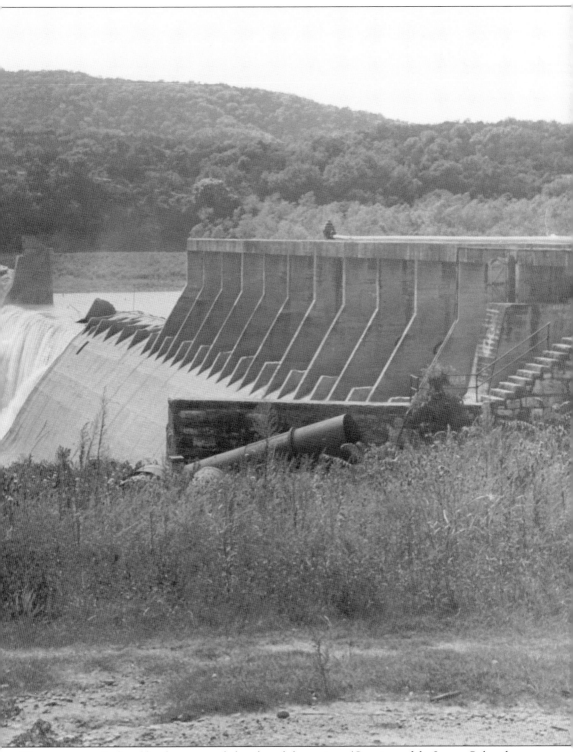

The contractor declared bankruptcy and abandoned the project. (Courtesy of the Lower Colorado River Authority.)

Never completed, the derelict dam became a thorn in Austin's side for years to come. The city sued the contractor, alleging shoddy workmanship. As the years went by, the dam silted up and debris accumulated around the spillways. Except for an occasional release of water to downstream rice farmers, it had little use other than as a picnic spot. The failure affected Austin's fortunes for years to come. Without sufficient electricity or water, Austin could not compete for industry or large government projects such as military bases. (Above, courtesy of the Jacob Fontaine Religious Museum; below, courtesy of the Texas State Library and Archives Commission.)

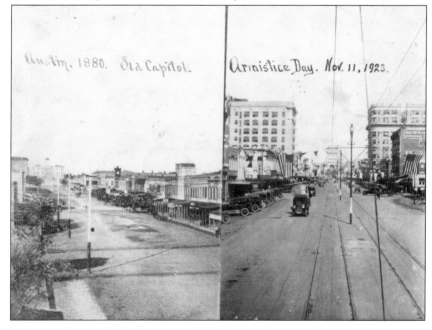

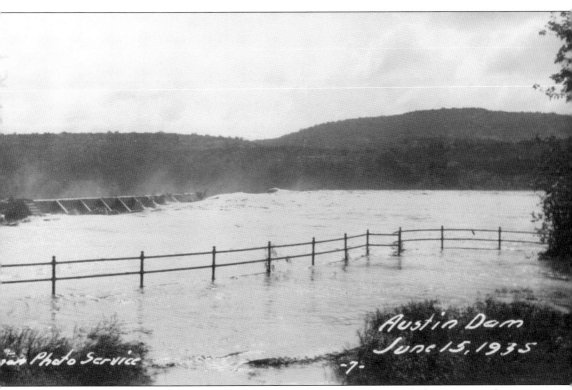

Austin Dam
June 15, 1935

Photo Service

-7-

The city finally regained ownership of the dam in 1933. The 1930s was a period of extreme weather, and Austin was hit by devastating floods in 1935, 1936, and 1938. The 1935 flood was the worst in Austin history, leaving 3,000 people homeless.

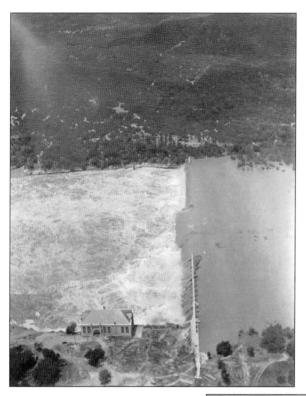

The event of September 1936 saw three successive monster storms keep the Colorado at flood stage for three weeks. Some neighborhoods were inundated with as much as eight feet of water. When the waters receded, the dam structure that still remained was left in ruins. (Courtesy of the Lower Colorado River Authority.)

Arguably, Tom Miller—the freewheeling produce dealer who served as Austin's mayor off and on from 1933 to 1961—did more to shape modern Austin than any other individual. Together with then congressman Lyndon B. Johnson, Miller crafted an agreement with the Lower Colorado River Authority (LCRA) to rebuild the Austin Dam. The LCRA was then a new entity charged with creating a system of dams and lakes on the Colorado with New Deal money. In a whirlwind of construction, the project began in September 1938 and was dedicated on April 6, 1940. (Courtesy of the Lower Colorado River Authority.)

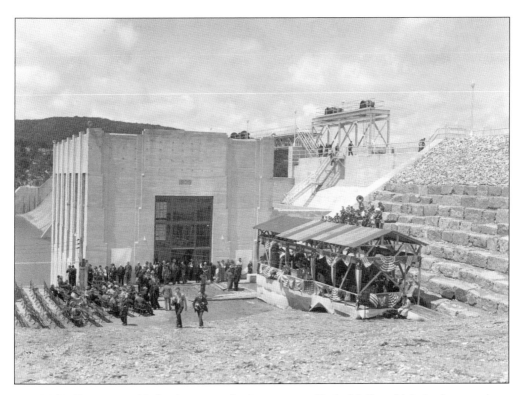

Tom Miller Dam created Lake Austin on the former spot of Lake McDonald. Lake Austin is kept at a constant level of 492 feet above sea level. The dam's hydroelectric generation is coordinated with Mansfield Dam, 21 miles upstream. Officially designated Austin Dam, the structure was known as Tom Miller Dam from the beginning. It was officially renamed in 1990. (Above, courtesy of the Lower Colorado River Authority; below, author's collection.)

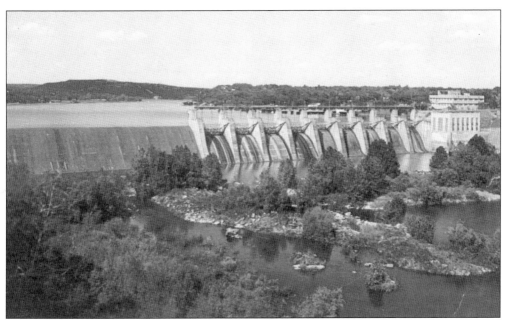